Sketchbook Pages

VOLUME 3
2009 - 2012

BY

Amelia Fais Harnas

SELF-PUBLISHED
IN CORNING, NY

© 2012 AMELIA FAIS HARNAS

ISBN: 978-1-105-87000-2

NEW YEAR'S DAY 2012: MY RESOLUTION WAS QUALITY NOT QUANTITY, WHICH IS A HARD LESSON FOR ME TO LEARN...

THE PAST THREE YEARS HAVE BEEN A TIME OF GREAT ACCOMPLISHMENTS IN A CONTEXT OF SOBERING FLUX AND FLUSTER...

THESE SELECTED PAGES SPAN: 2 SKETCHBOOKS, APPROX. 15,000 MILES, 9 EUROPEAN COUNTRIES, 53 MUSEUMS, 3 ALBUMS RECORDED, 4 LIVING SITUATIONS, A 5-DAY ART FESTIVAL, 1 NEON DRESS, THE DEATHS OF 2 PEOPLE WHO MEANT SO MUCH TO ME, 1 GODSISTER, 7 NEW KINDRED SPIRITS, $700 WORTH OF FIREWORKS, 2 BB GUNS, 2 SUCCESSFUL KICKSTARTERS, 2 EGGS WHITE TOAST & 1 PANCAKE, AND 1 ORANGE RIBBON THAT EMERGED FROM ITS HIDING PLACE DEEP IN MY ROOTS.

AGAPE ∞ START OVERS

·6 12 12

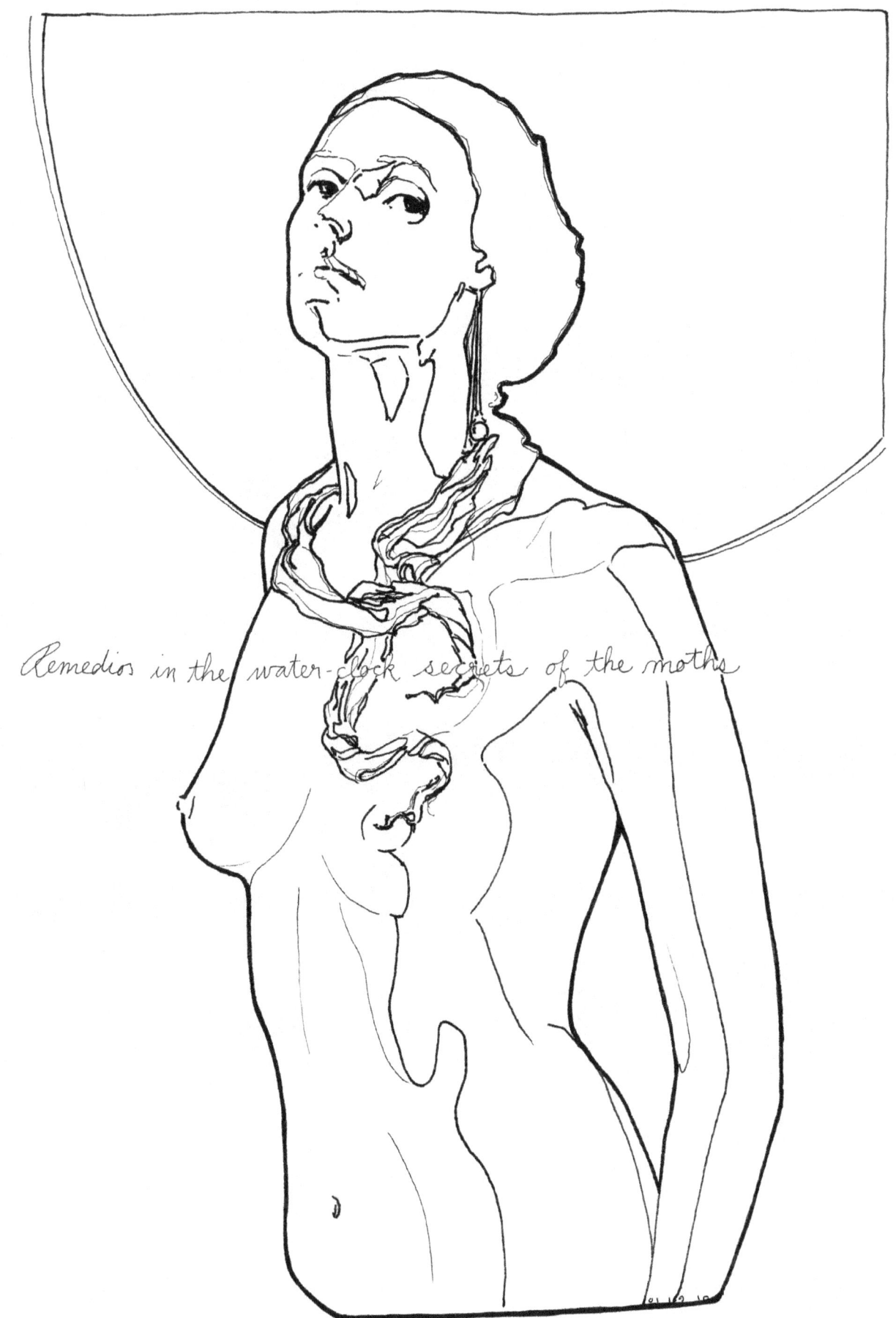

Remedios in the water-clock secrets of the moths

September 2009

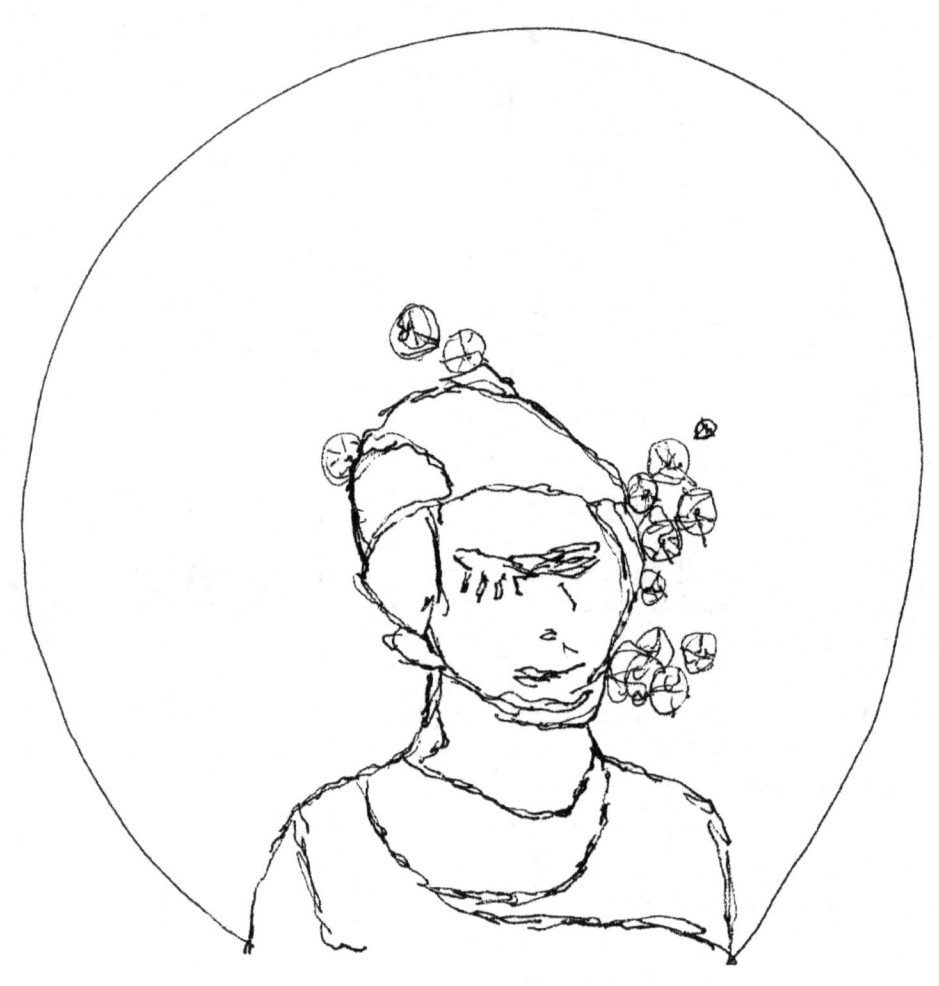

O, Saint Eustracnius, patron saint of difficult choices, hear my prayer: i have cried so much today that my nose is bleeding. Come to me in a dream tonight and show me the way. But don't make me die. I don't want to die just yet. Come to me in a Frank Capra-esque dream instead if you must.

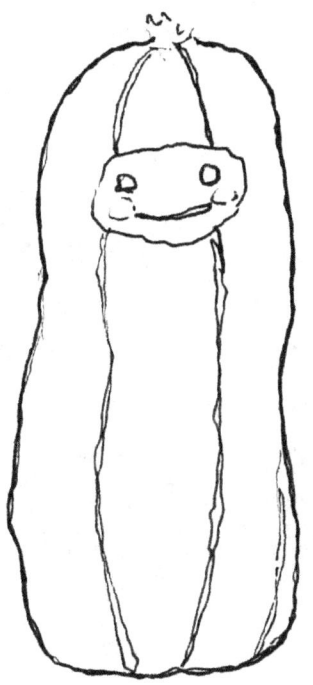

O, big pickle and amused moon, keepers of perpetual smirks, hear my prayer: i have smiled so much today on behalf of others' good fortune and fortitude. Smile upon me with equal grace. Kindly remind me that we're all trying — it's just that I'd rather be on the side where the laughter always is the period. Or maybe, more like it — the comma of my favorite, the elipsis ...

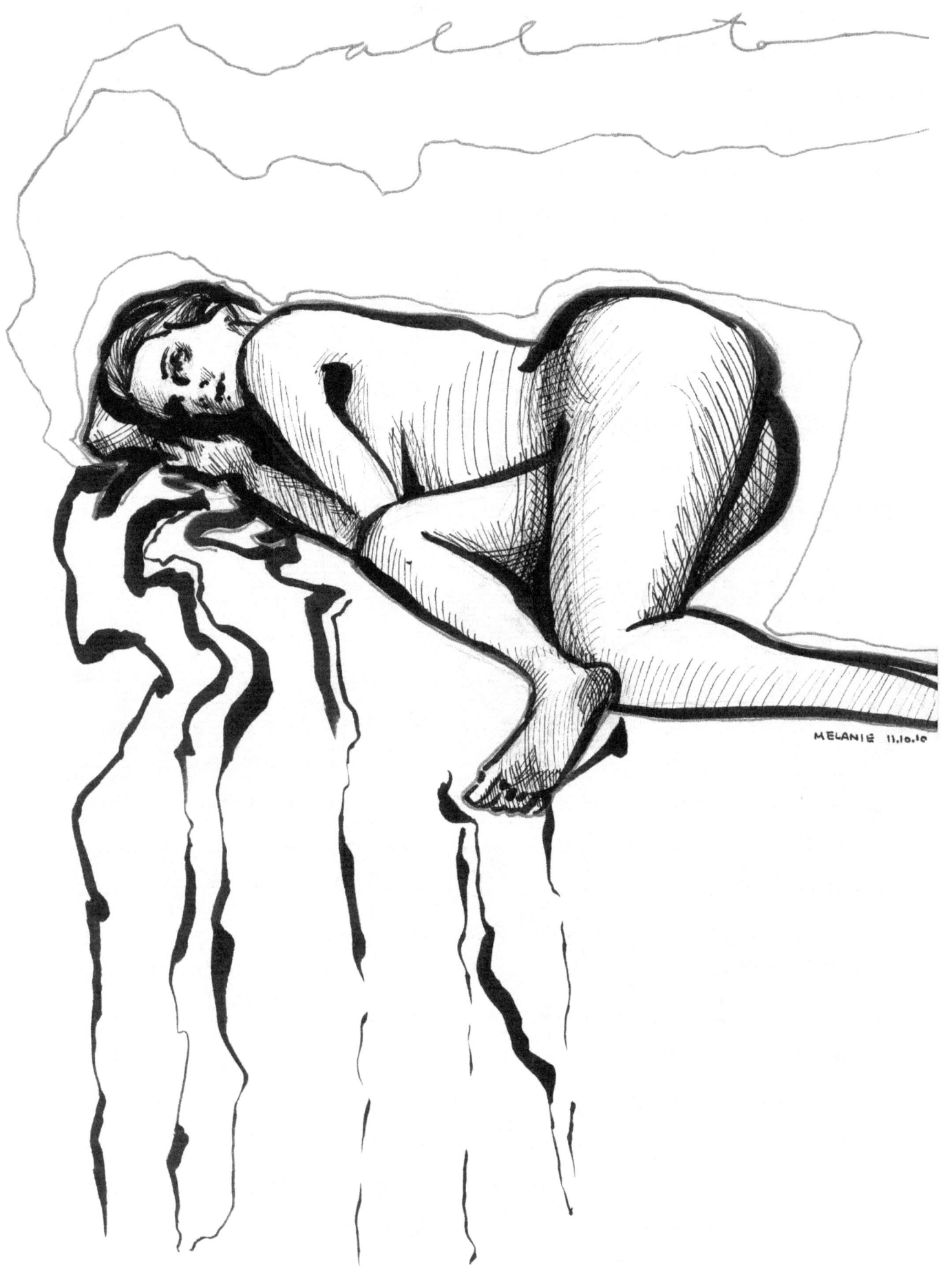

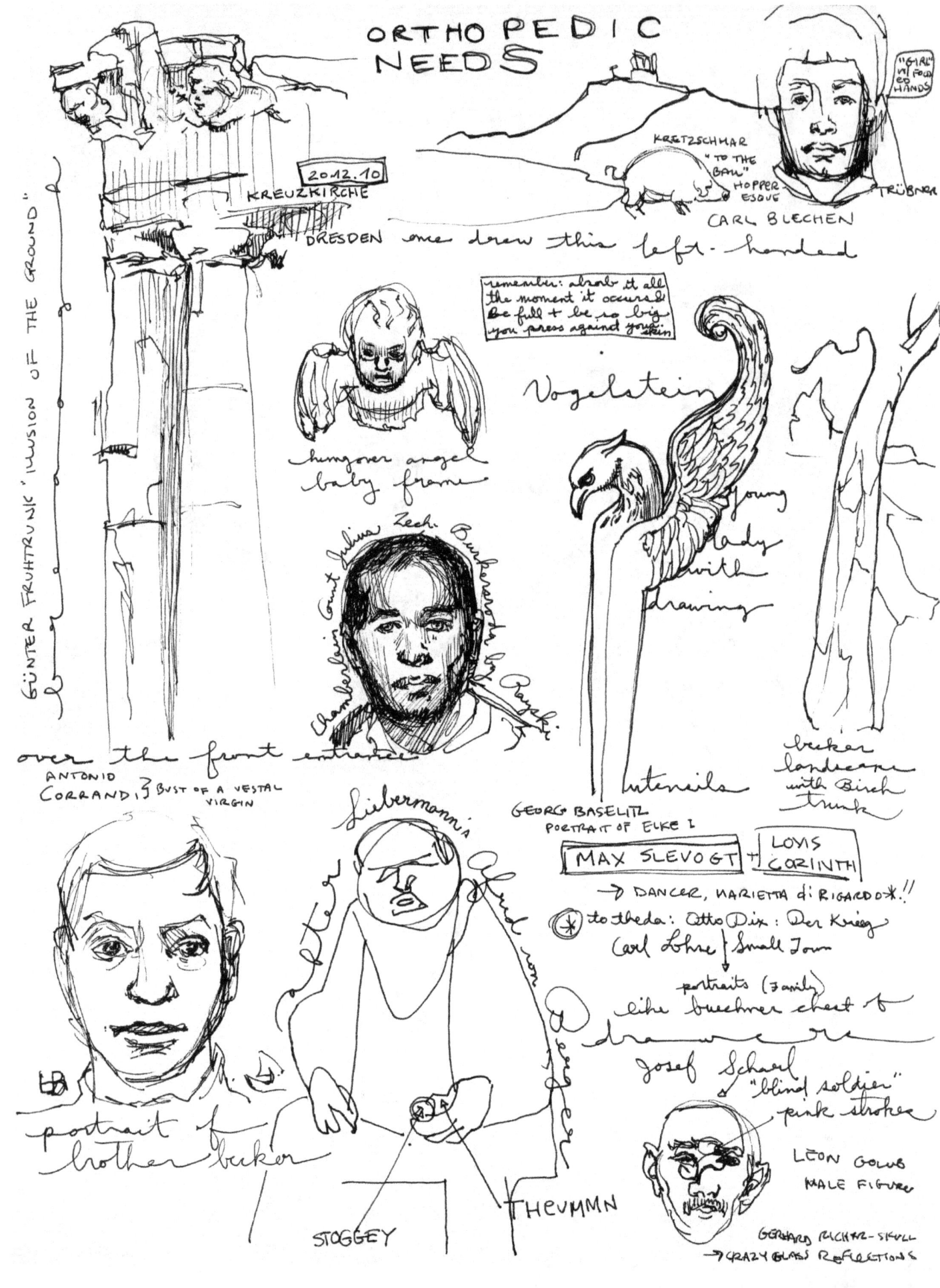

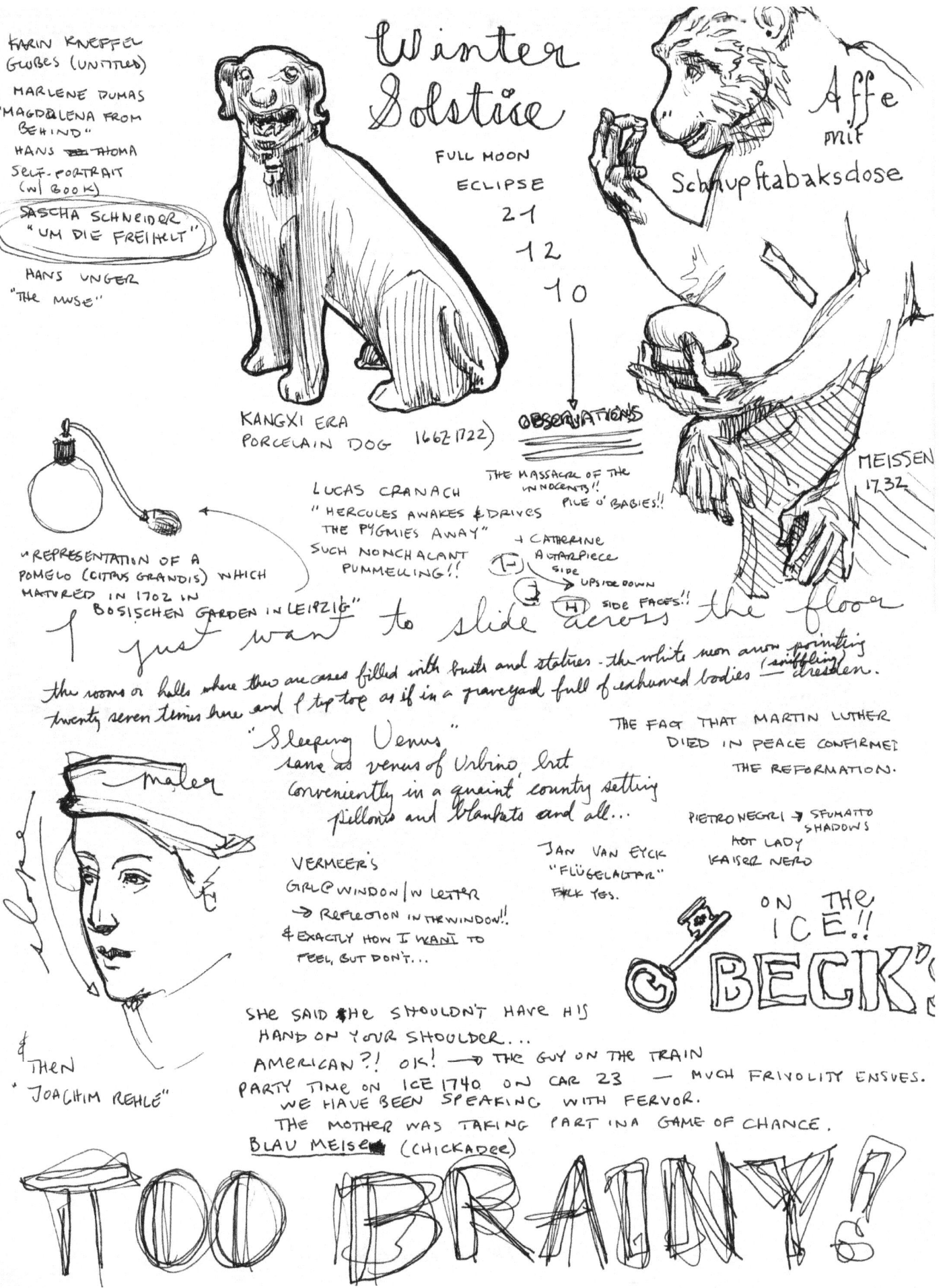

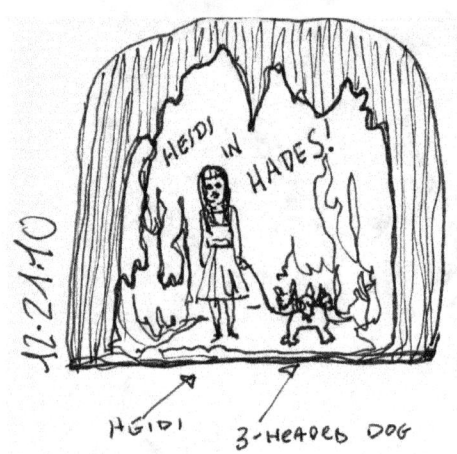

12.21.10 — HEIDI / 3-HEADED DOG

29.12.10
I will name my children with middle names after rivers:
SQUANTO ELBE HARNAS
GIGANTOR ST. LAWRENCE "
CHUCK SNAKE HARNAS
NANCY MONONGAHELA "
WEEFY MISSISSIPPI "
MARFA DANUBE-RHINE-RHONE

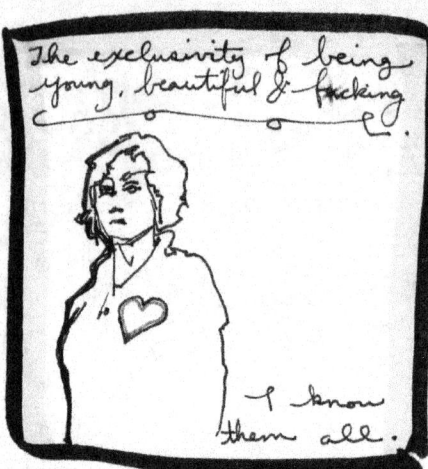

The exclusivity of being young, beautiful & fucking.

I know them all.

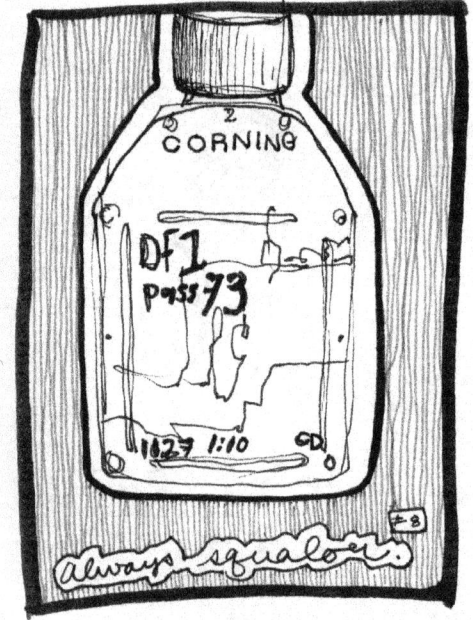

always squalor.

1

CHRISTMAS MIRACLE

Bluffle off lil' doggie!!!

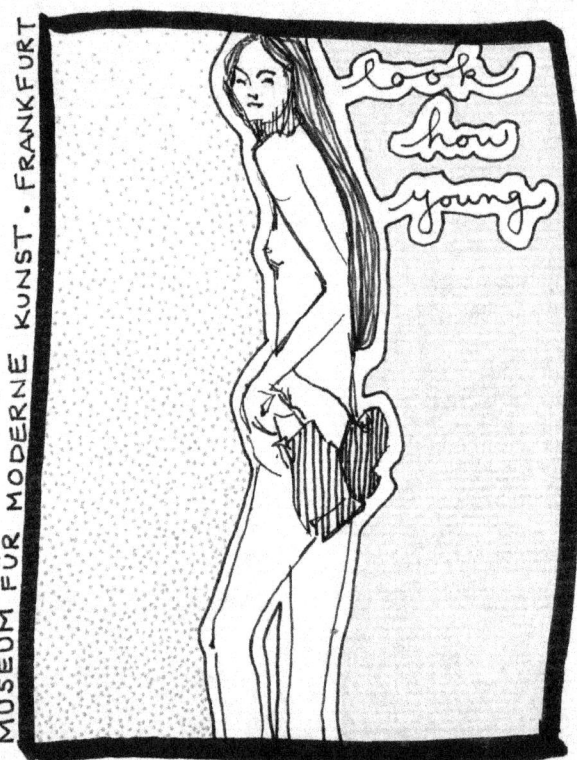

MUSEUM FÜR MODERNE KUNST · FRANKFURT

look how young

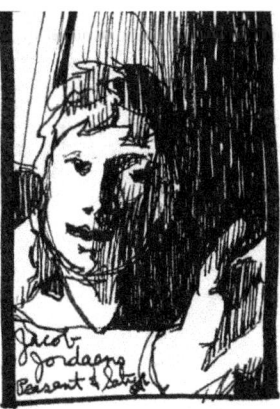

Jacob Jordaens
Descent of Christ

I NEED A MUSEUM SYSTEM AT THIS RATE - OY!
1) sit down every once in a while & stare into space 2) eat right before & after 3) have a snack on hand as much as possible 4) stretch back and neck 5) don't let people looking over your shoulder bother you. They probably aren't Tom Buchners — just regular folk. 6) sketch!

Brueghel's branches
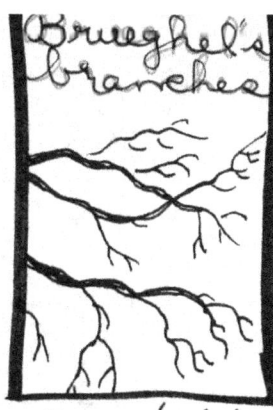

02.01.11

cherub

why is it so tragic to me? the sex, the beautiful faces and bodies, the art that went with it, plus the drugs — I have met that and it scared me. Meeting it here — paying admission to see documentation of it — I feel as if I somehow wound up at the cool party and shouldn't be there. I don't belong in such irreverence.

29.12.10

chillaxin' it

Hendrick van Steenwyck der Jüngere → Higgins dark interiors of domes & little children always pee at parties. Jacob Jordaens 'the death of Cleopatra' dragon snake biting nipple!! Frans Hals man in the slouch hat: whites & greys.

It's a funny squeaking sound (my boots in museums thus far). Bookshelf decal?! Carlo Caio — beautiful etching blue paper & white & black!! — brown. Louis Kolitz. Tintoretto — young man. Carpioni 'Venusfest'. Franceschini — Charity bird tied to a string, lady holds it in flight — so crazy.

Rembrandt self-pro copy

as of 30.12.10:
KASSEL → PARIS
PARIS → BRUSSELS
BRUSSELS → ROTTERDAM
DELFT? DEN HAAG?
AMSTERDAM → BERLIN
BERLIN → PRAHA
PRAHA → WIEN
WIEN → MÜNCHEN
MÜNCHEN → VENEZIA
VENEZIA → FIRENZE
FIRENZE → BARCELONA
BARCELONA → MADRID
MADRID → GRANADA

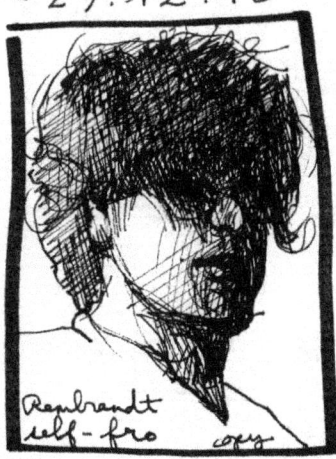

Luca

whoo

(with shaded eyes) soft light soft soft?! Cornelis van Poelenburch Martyrdom of St. Lawrence — seen as composition as David's death of Socrates. van Dyck — purple-y grey for 5 o'clock shadow — everyone is always looking up and to one side for Rubens — mouth slightly open & more yellow & waxy... Marten Popyn — Red Sea fucking intense!! Shit! Utrecht — "A kitchen piece" crazy swan w/ crossed pierced bill in basket!

but why is it so, so tragic to me? They are beautiful and it is art and I believe in beauty & art, but why not in them? Is it because I know they are probably still alive, working regular jobs & taking care of their own children? Is it because some of them may still desperately cling to that life, 20 years later? Is it because some of them might be dead? Is it because I am not one of them?

29.12.10

PAINT ONLY
WHAT YOU NEED TO
SURVIVE

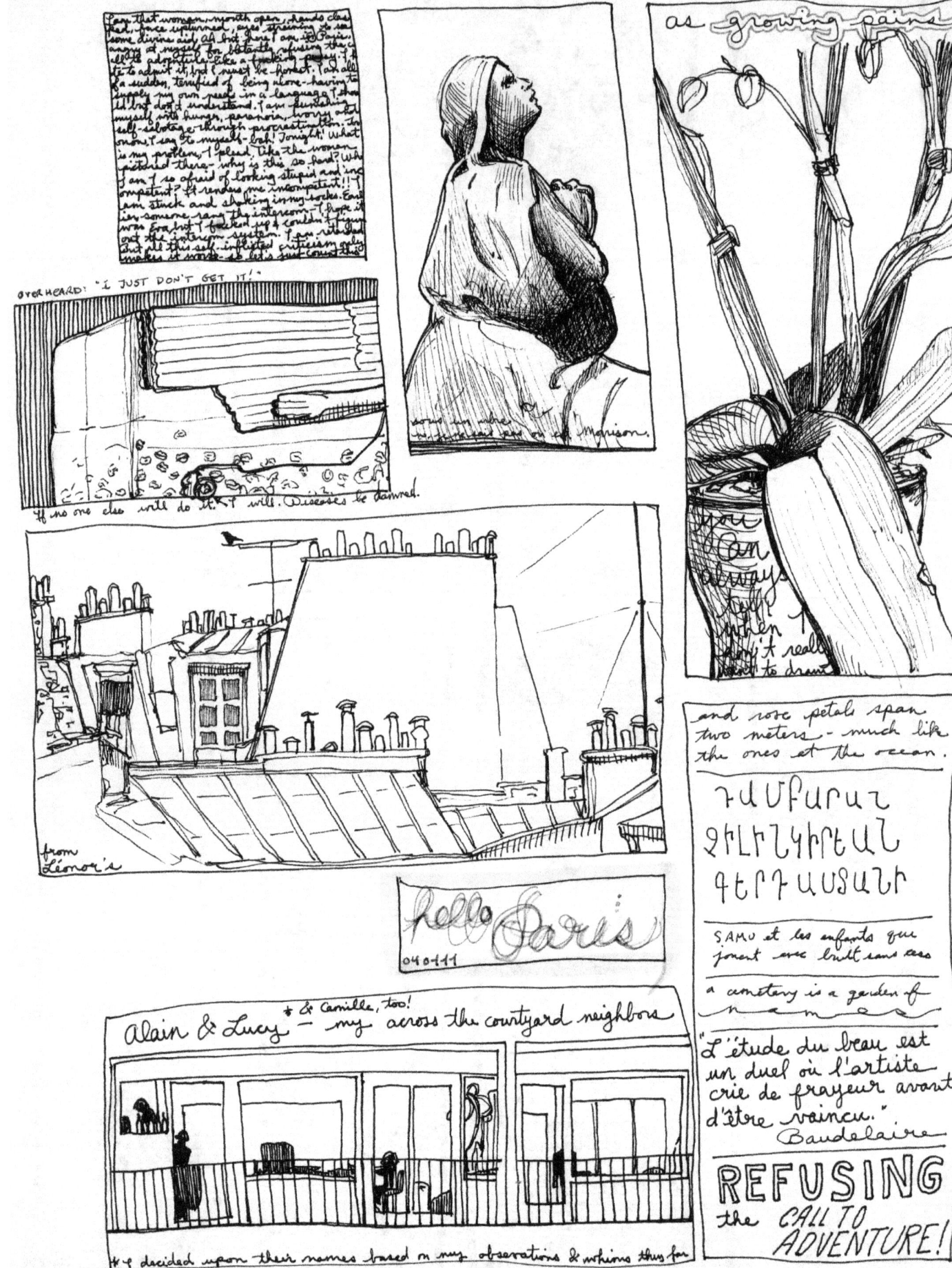

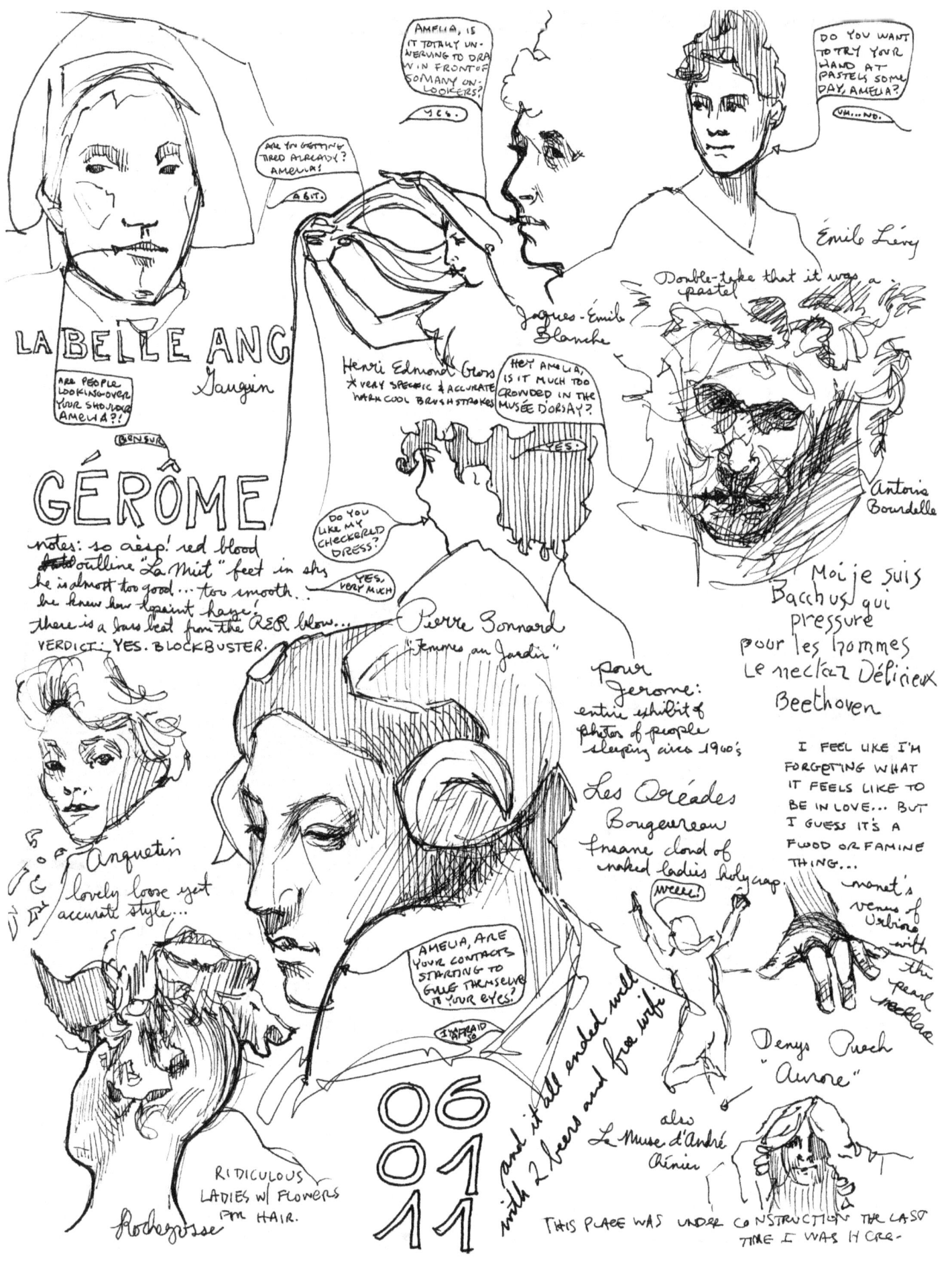

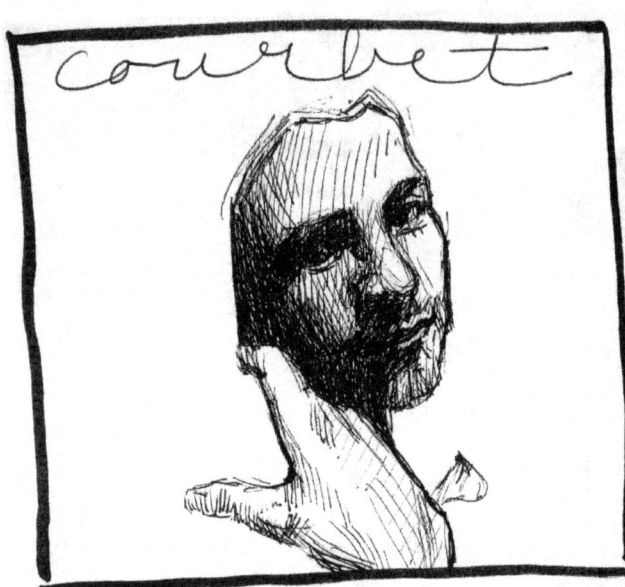
Patrice Chéreau

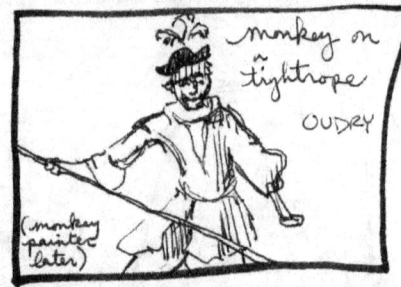

Jacques Stella - Muses - yellow & blue / teal & brick for light / dark woven / cool in fabric - stunning! • Fragonard so loose! so right in - red - purple brown underpainting so wrinkly and dynamic. Observation: when I choose to draw something, it causes more people to stop and look at it - one tourist even quickly took a picture of me drawing! I'm sure others have as well, I just didn't notice, because I was drawing. Regnault les trois graces

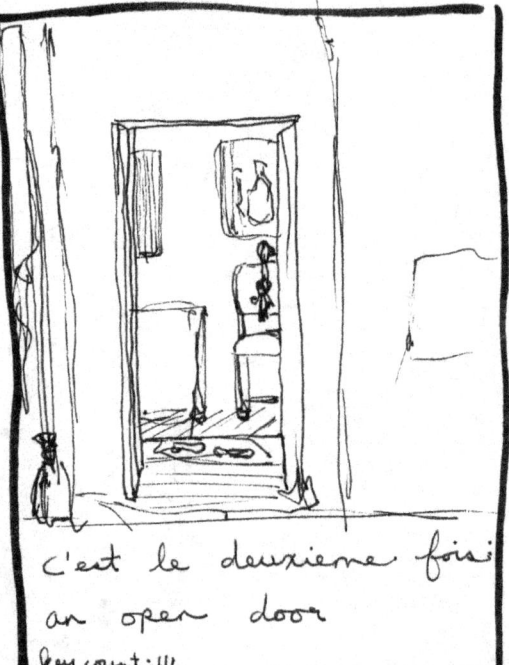
c'est le deuxième fois an open door
key count: 1/1

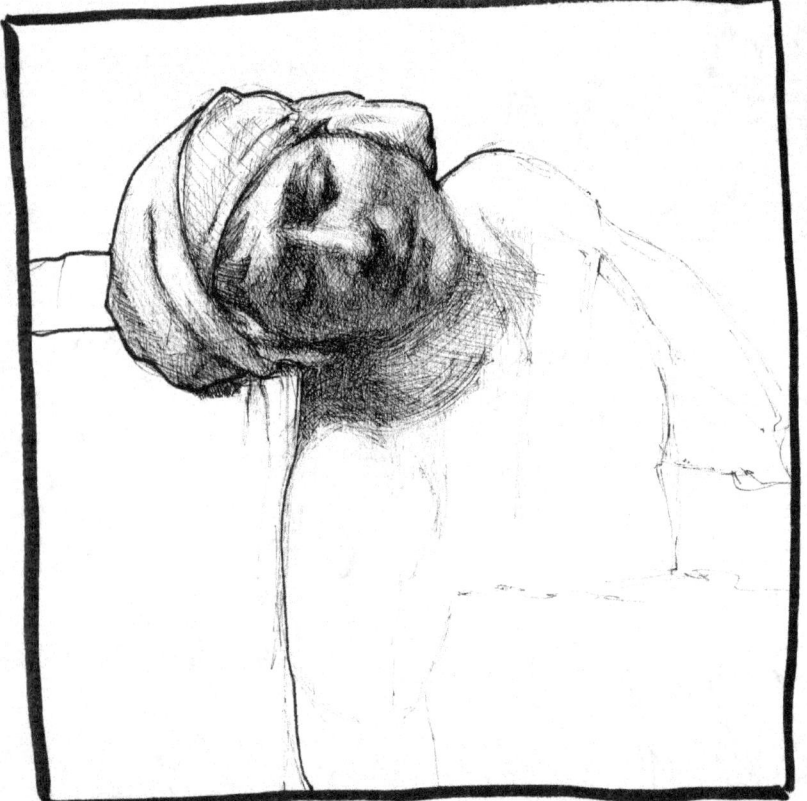

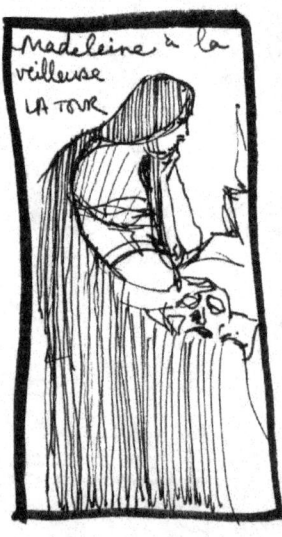
Madeleine à la veilleuse
LA TOUR

"N'AYANT PU ME CORROMPRE ILS M'ONT ASSASSINÉ. DAVID'S MARAT [FIRST TEARS AT A MUSEUM] so much dark gray - the hand & pen. Boilly - tiny portraits!?! Flandrin's portraits!!! 'The light in progress' Turkish bath - golden - all the rest gray. François Gérard aurora borealis

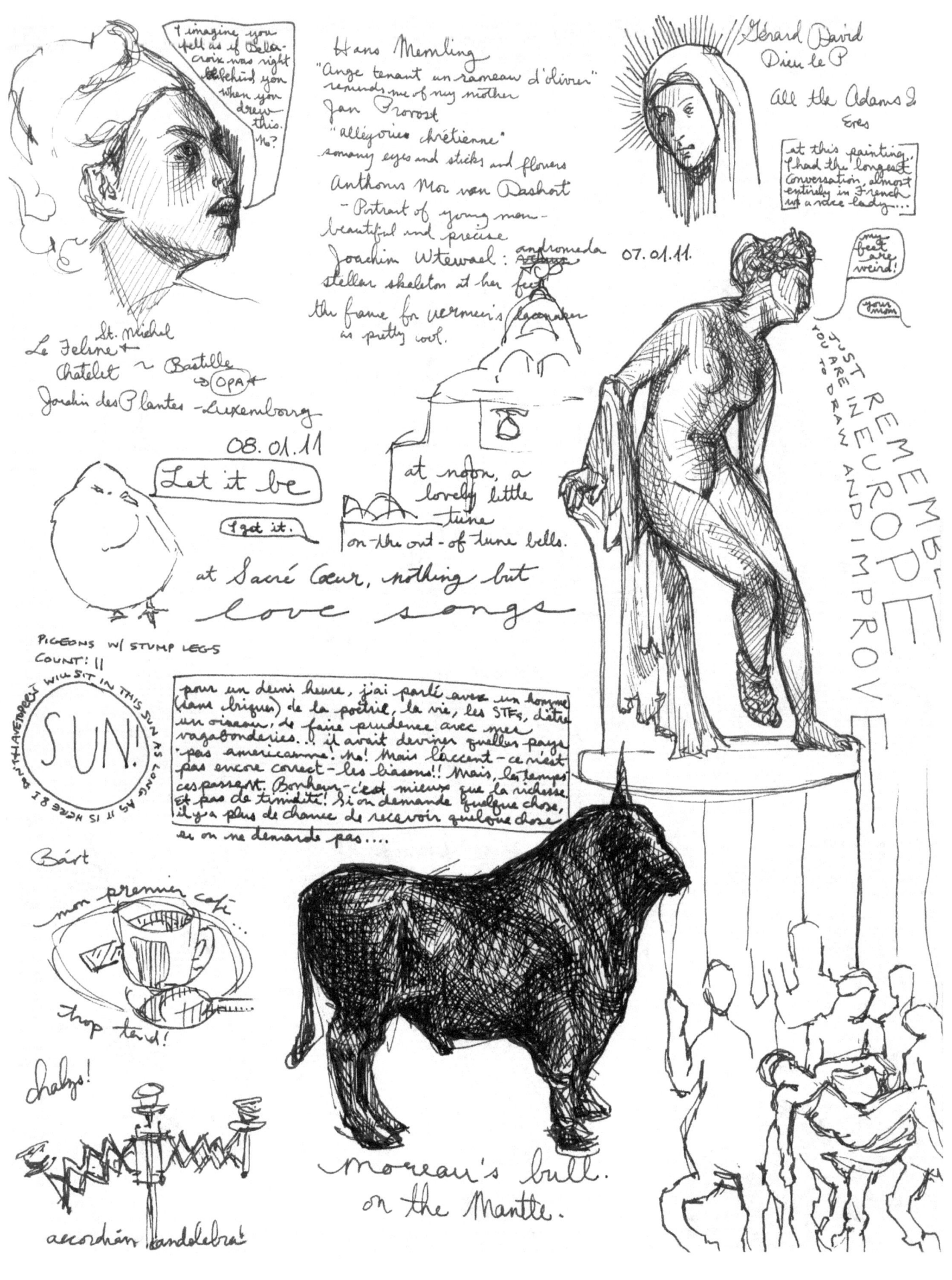

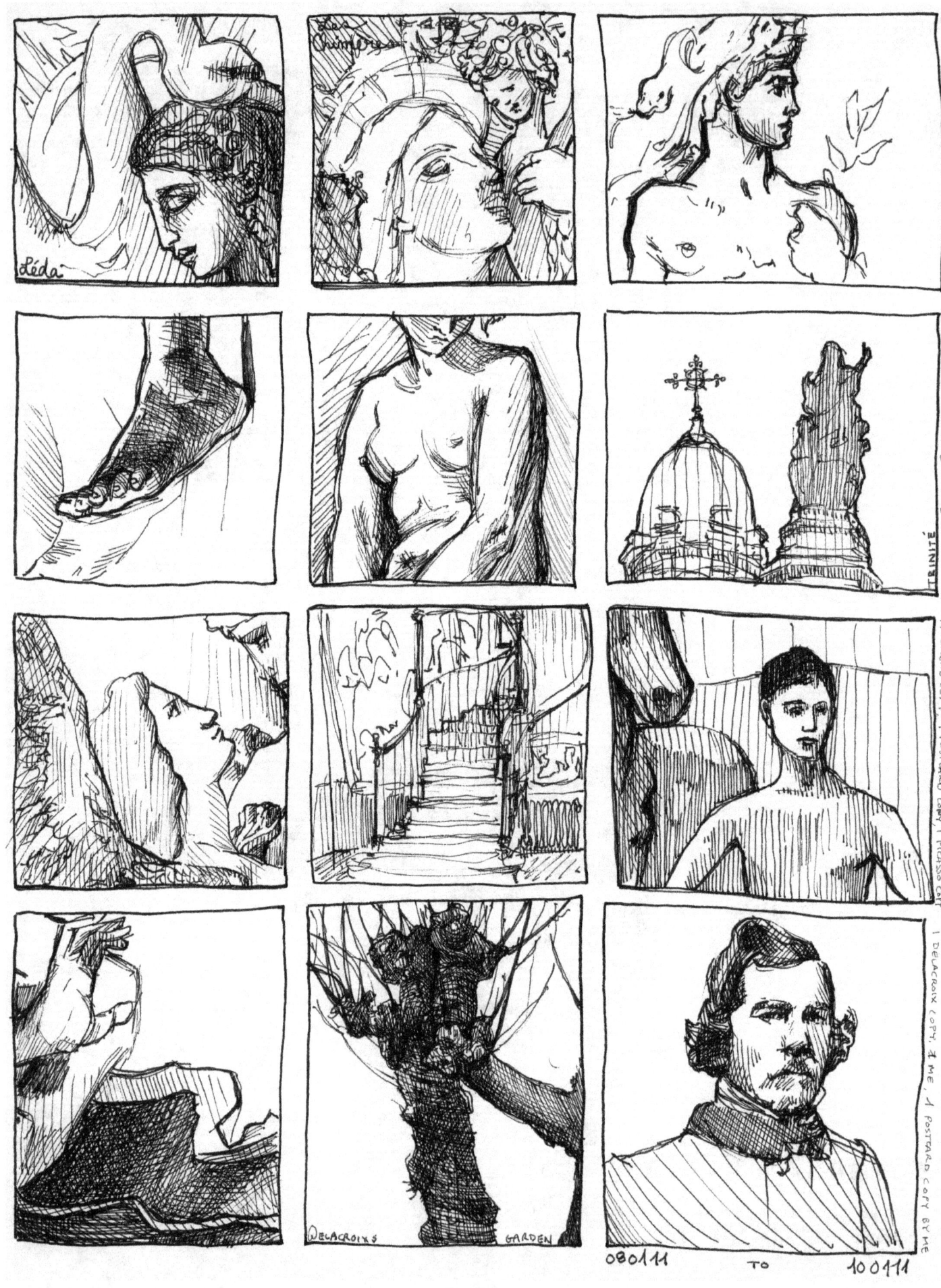

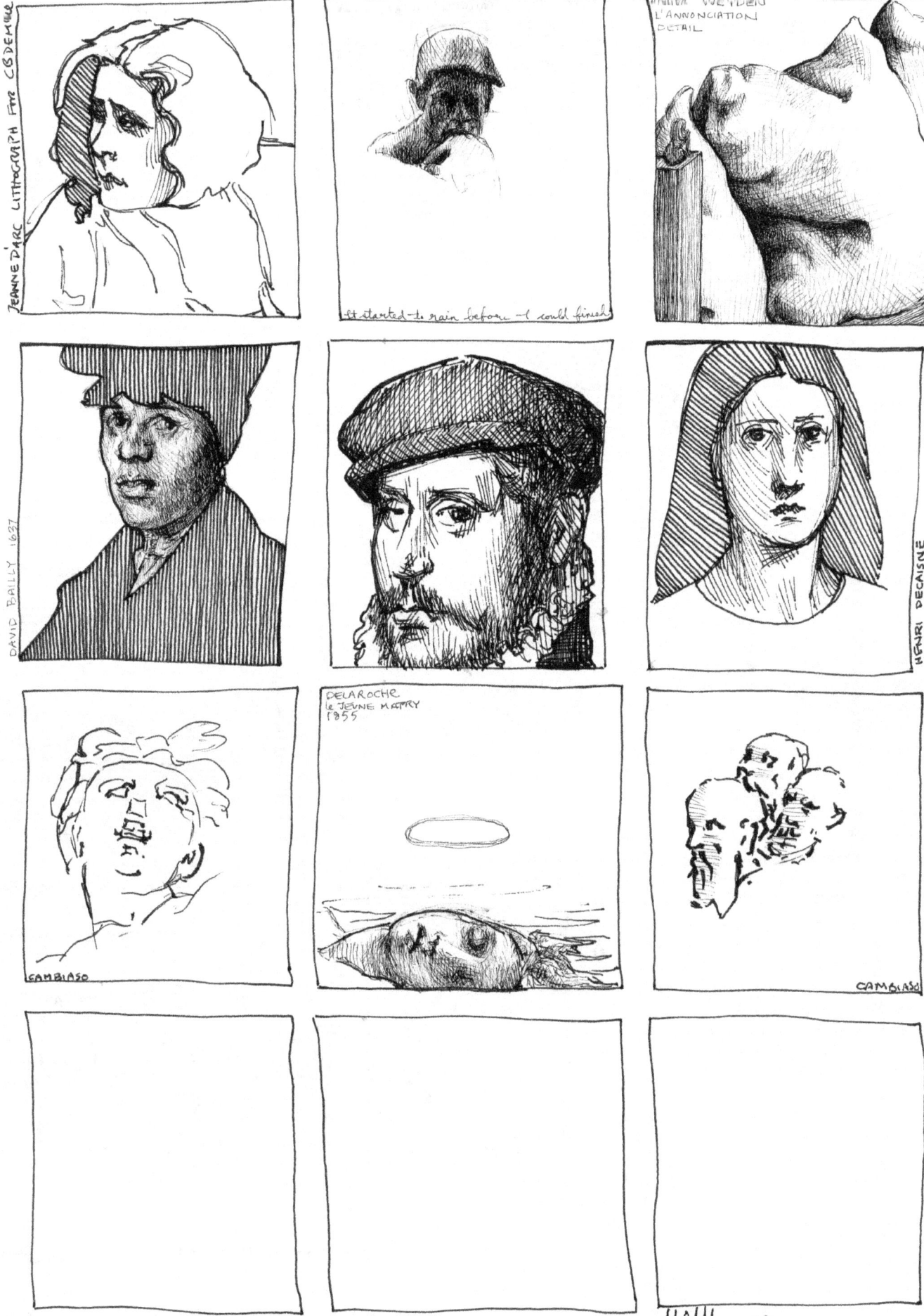

GALLUP NM — EL RANCHO

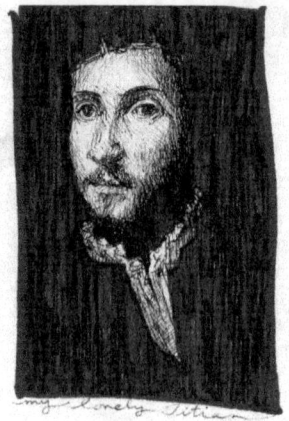

my lovely Titian

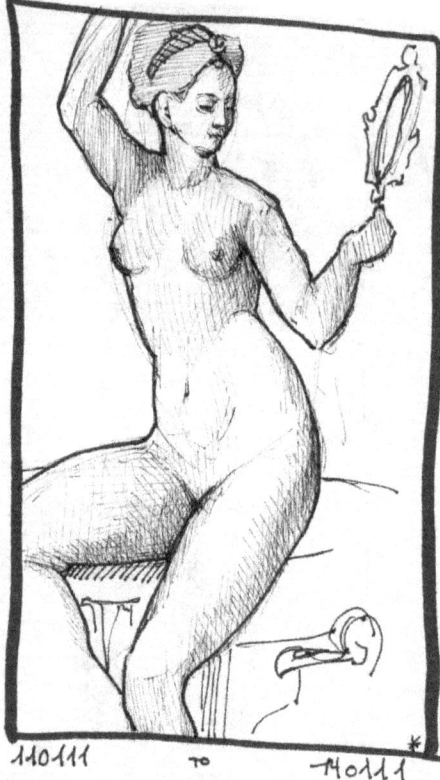

110111 TO 140111

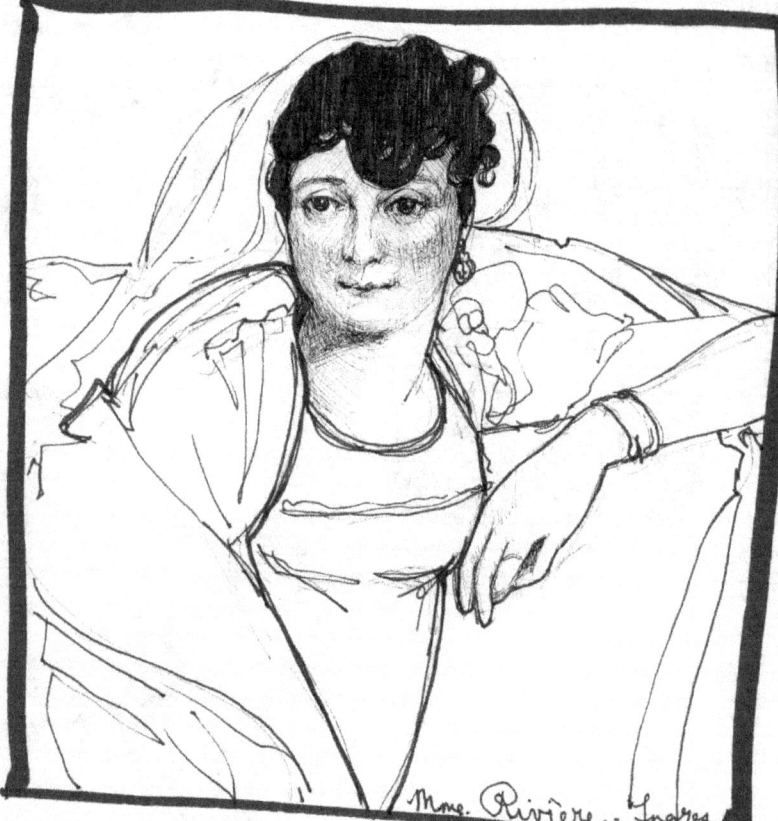

Mme. Rivière - Ingres

Si Paris Nous Etait Conté - Napoléon
Le Roi Danse - La Belle et la
Bête (encore) → Talking about Enfer.
The kiss Paolo & Francesca - Eugène
Carrière: warm glowing grisailles

houx AH HOLLY FAM'LY
 RENCONTRER
POURRAI-JE G. François
Dee BAY Clouet!
 so soft...

École Fontainebleau - Venus à sa toilette*
mais désolée pour la petite tête...
Poussin - almost like paint by number!!
I like Van Dyck (not Pke)
doing more vile soaking than drawing
Ingres is just so goddamn smooth!

It is the softness that makes a difference
Da Vinci is so dark! Did he smoke a lot?!
Veronese - Jesus threw one hell of a party!
→ Jupiter punishes the vices. awesome falling!!
I love so much how Titian's portraits speak to
me - black on black, face as a mask but perfect...
I must remember to experiment with azure +
yellow/magenta as light/dark. warm blue -
cool magenta. Francia light - Portrait of a
man (rock star) on yellow & pink. Luca Cambi-
iaso drawings temp. exhibit - Louvre
Reni: good fleshy flesh - vermillion, I think
Sanglier - Boar. Now in Musée Branly -
I followed the path of a river of ghost
words up to all of the artifacts. In the
métro, between Havre and Léna feverish
accordion playing accentuating the flicker
of the electricity & squeal of the tracks

Got up on the wrong side of the bed today 130111

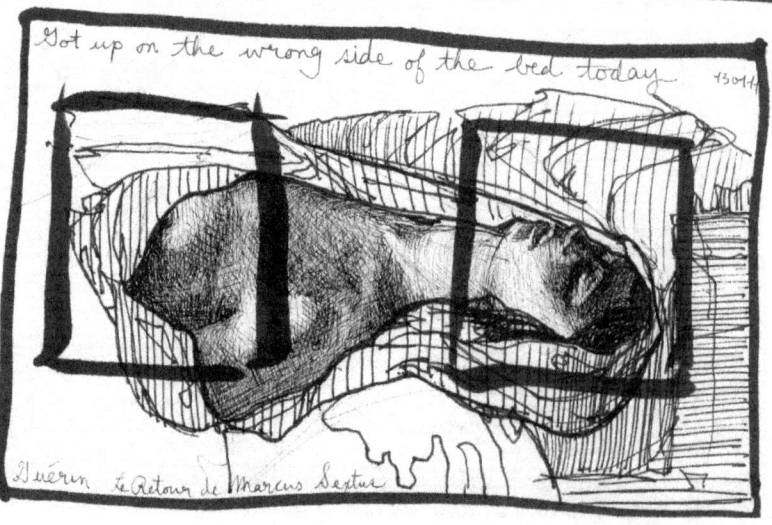

Guérin - Le Retour de Marcus Sextus

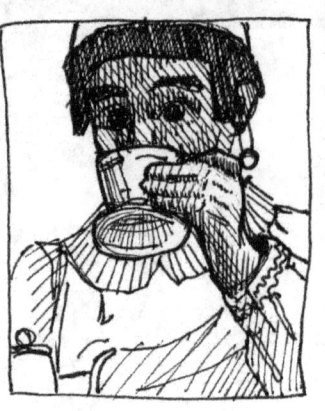
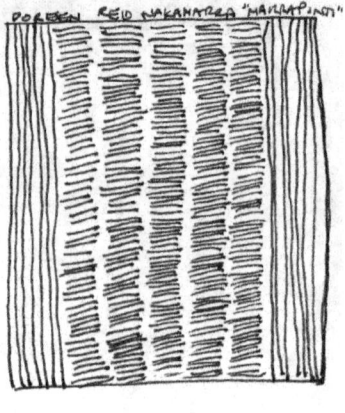

DOREEN REID NAKAMARRA "HARRAPINTI"

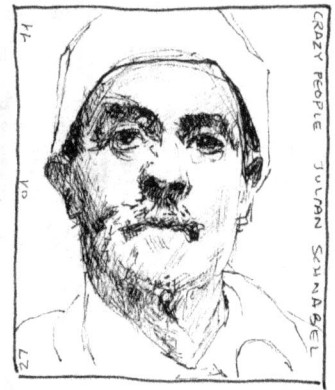

CRAZY PEOPLE JULIAN SCHNABEL

C FABRITIUS 1654

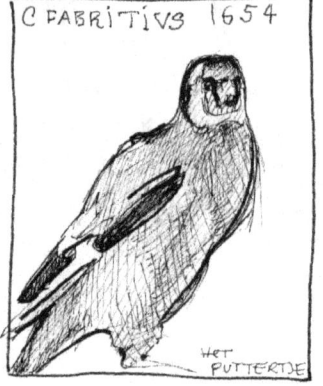

HET PUTTERTJE

WHILE I AM HERE, AT LEAST!

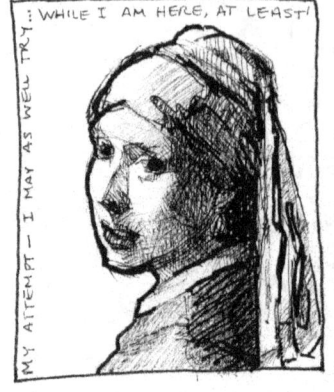

MY ATTEMPT — I MAY AS WELL TRY.

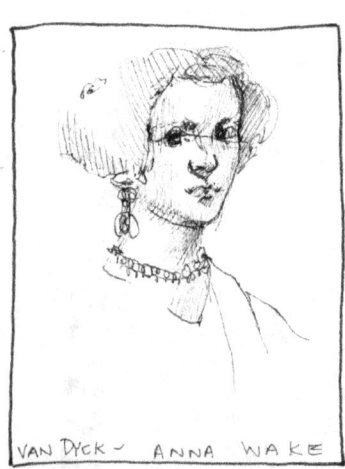

VAN DYCK — ANNA WAKE

It is the eye in the self-portrait of Rembrandt from 1669 that makes the painting — the flesh is all sculpted around it yet the light on the iris and in the eye are perfect — like it is peering out from the painting. And the one of him in the feathery hat — a little bit of Hals's style with the slender, pointy strokes — strokes follow the form — texture, too. He loves the shaded eyes & 3/4 face. And then, in the anatomy lesson, again flawless flesh but it is the expressions and the positioning of the faces that makes it so interesting. And those warm yellowy grey green backgrounds — that shift, a fine gradient. Makes such a crazy contrast in the one with the feathery hat. I went to draw that one later. Well — it's really good — I need to focus.

PANORAMA

NORTH SEA

DEN HAAG

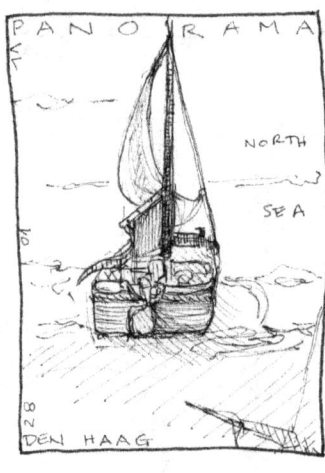

(KING & TOUCHSTONE)

WERNER VAN DEN VALCKERT

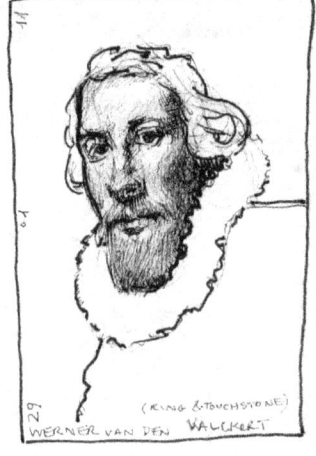

JAN LIEVENS — JF CONST. HUYGENS

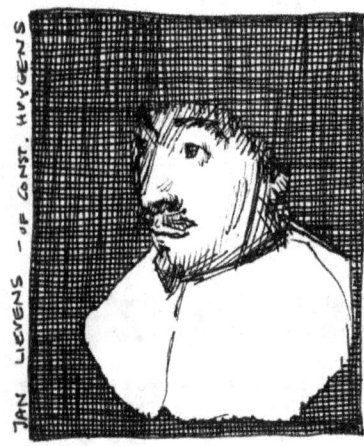

TOULOUSE-LAUTREC WOMAN IN GARDEN

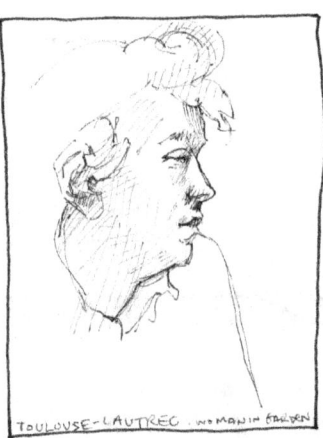

FOAM

AND SO IT IS SO COLD WE ARE DRINKING COFFEES AND EATING POFFERTJES AND TALKING ABOUT WHAT MUSEUMS ACCEPT THE MUSEUM CARD AND HOW I WANT TO FINISH THIS PAGE TODAY BUT IT IS HARD BECAUSE THIS CORNER IS TOO FLOPPY AND THEY ARE PLAYING A STING SONG & AND THE MENUS HAVE THESE ALUMINUM EDGES THAT SEEM LIKE THEY COULD DO DAMAGE IN THIS LITTLE OPEN EXIT TO THE I AMSTERDAM SIGN. I PROBABLY HAVE POWDERED SUGAR ALL OVER MY FACE. I HOPE THAT THIS PAGE DOESN'T FALL OUT AND GET LOST THAT WOULD BE VERY AWFUL TAKE MY BREATH AWAY IS PLAYING NOW AND WE ARE GOING TO THE FOAM PHOTO MUSEUM NEXT THEN MAYBE VAN LOON THEN THE HISTORIC MUSEUM WHICH PUTS MY MUSEUM COUNT AT THIRTY ONE. THEN BERLIN TOMORROW ON A MONDAY AND THEN I HAVE TO MAIL SPRINKLES...

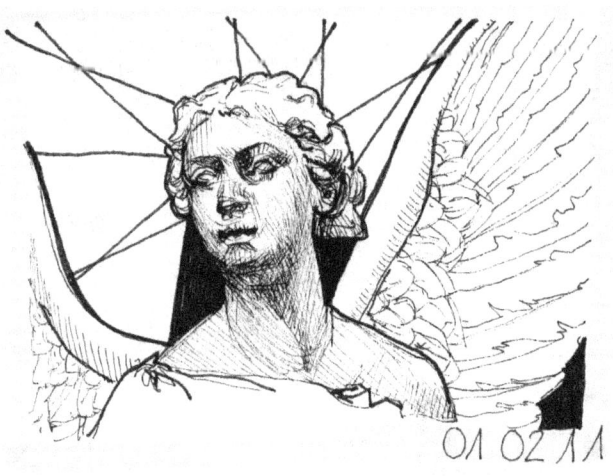

01 02 11

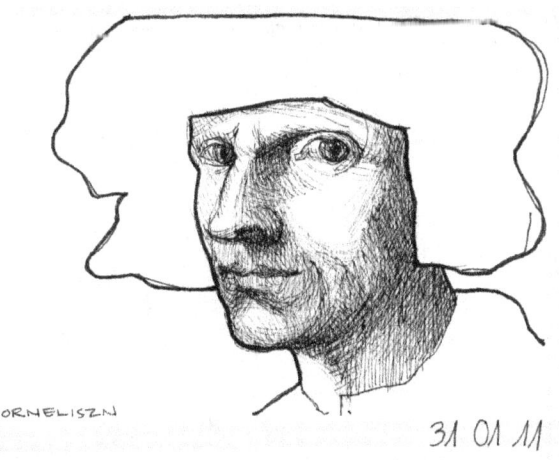

JACOB CORNELISZN

31 01 11

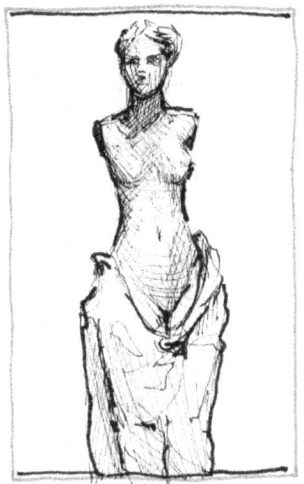

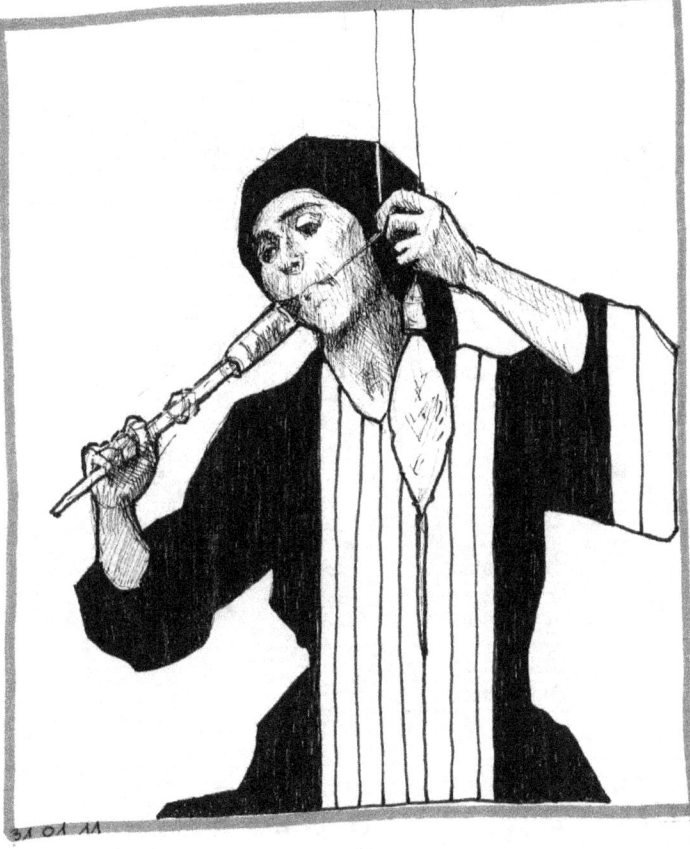

31 01 11

ODILON REDON: FIGURE UNDER A BLOSSOMING TREE. WHISTLER: EFFIE DEANS. CHARLES LAVAL: SELF PORTRAIT 1888. VAN GOGH: PORTRAIT OF OLD MAN 1885. ALL OF HIS SHOE PAINTINGS. 29 JAN '11 THE BOOK: 72 MUSEUMS — 1 PAGE EACH W/ DRAWING OF MUSEUM ITSELF / 1 OR 2 PIECES + COMMENTS & A JINGLE YOU GOTTA MAKE A MOVE, IN THE LOUVRE 'COS THERE ARE SO MANY ROOMS SOMETHING X 3'S ALLRIGHT

211 YEAR OLD WHALE • FRISIAN • OLD GERMAN ··· WALTER LEISTIKOW "LAKE GRUNEWALD" REMINDS ME OF TOM GARDNER. MAX KLINGER. VENUS/TRITONS & NAIADS. IT'S ALL ABOUT HOW YOU PAINT SATIN! AMAZEMENT!. I FOUND A RENOIR THAT I ACTUALLY LIKE! "SUMMER" 1868 — IT'S A CHRISTMAS MIRACLE! JOHANN ERDMANN HUMMEL — GRINDING OF THE GRANITE BOWL

02 02 11: SOREST NECK EVER — DON'T KNOW WHAT I DID! SLEEPING WITHOUT A PILLOW MIGHT NOT BE HELPING BUT CAN'T BE HELPED. WALKED AROUND THE GEMALDEGALERIE LIKE A ZOMBIE, HENCE NO DRAWINGS

JOAN FONTCUBERTA • LANDSCAPES WITHOUT MEMORY • EUGENE SMITH • A PHOTOGRAPHER IN PAIN. THE PAIN OF PERFECTIONISM AND THE IMAGES HE CAPTURED... "THROUGH THAT COMPROMISE, HE WAS FORCED TO ADVANCE HIS CAPABILITIES". DOCTOR (CRIPPLE-MAKER) IN AFRICA. I DREW THE "SPINNER" WHEN I WAS IN HIGHSCHOOL. IT WAS SUCH A SURPRISE TO SEE THIS IMAGE AGAIN — TO DRAW IT AGAIN AND THEN TO LISTEN TO THE MAN'S SLURRING VOICE — TO HEAR THE PAIN OF STRUGGLE IN HIS WORDS

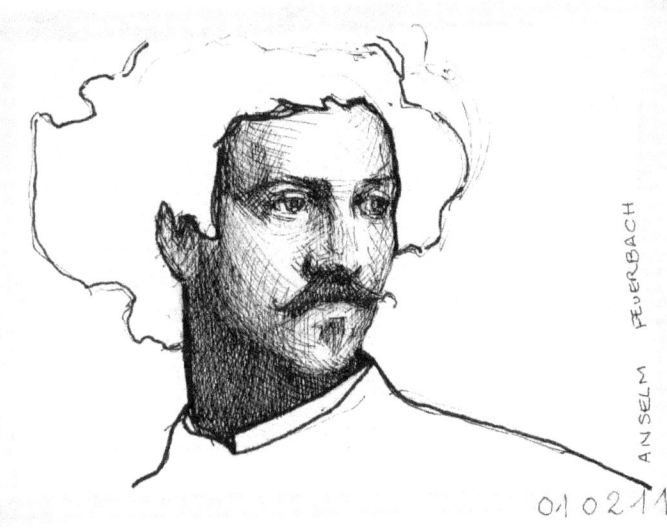

01 02 11

ANSELM FEUERBACH

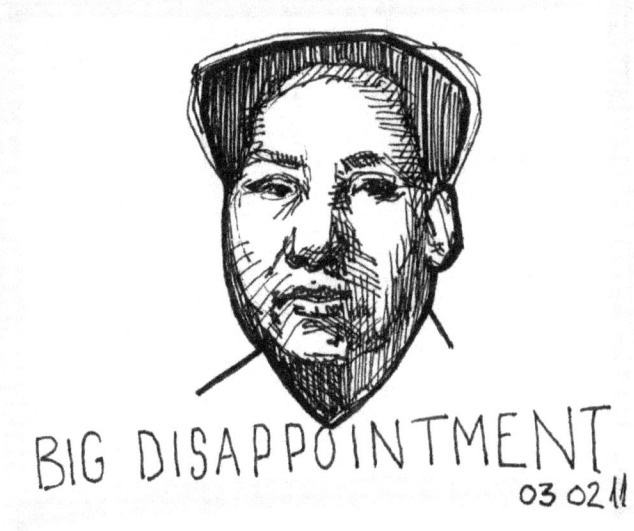

BIG DISAPPOINTMENT

03 02 11

FAMOUS AUNT MILLIE'S CHILI & CHEESE NECK FAT!
TURKISH TONGUE TWISTER "SHALL WE PRESERVE THE YOGURT WITH GARLIC OR NOT WITH GARLIC?"

Şu yoğurdu sarımsak-
lasak ta mı saklasak
sarımsaklamasaktam
sakladsak

ş→sh ğ→p ı→EWGH
04

DIE ANTWERP
DIE ANTWOORD
THE ANSWER

Kryzstof Zanussi
Iluminacya
Struktura Krystali

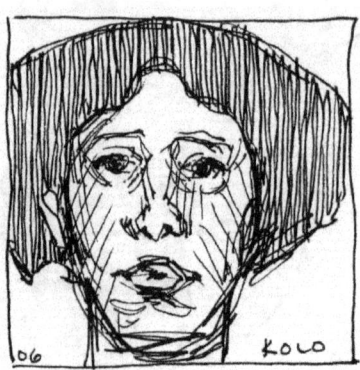
KOLO

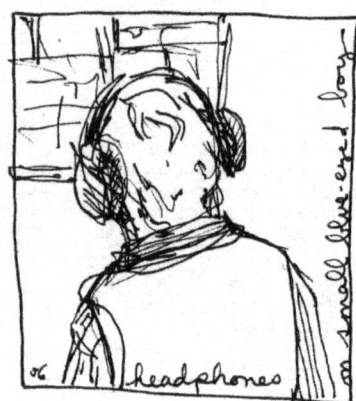
headphones

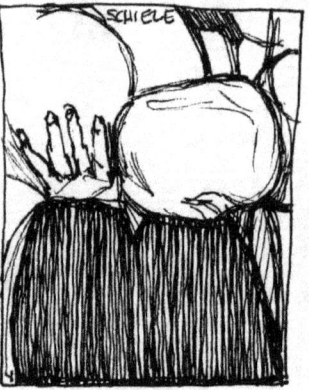
SCHIELE

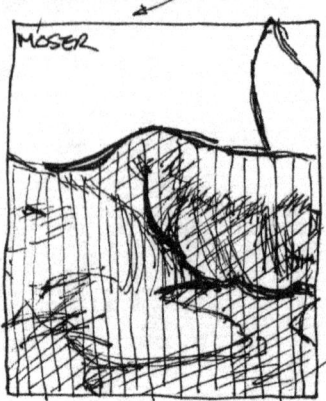
MOSER

SERGIUS PAUSER

Wally was actually pretty homely looking in a lot of the photos... surprising..... and now I see how he is peering down into my chest and into my heart asking, "what do you have in there?" Apparently, I really like Koloman Moser's work: "Venus in the Grotto" purple pastel shadow with yellow skin — whoa Carl Otto Czeschka! Having a rough day — what are the chances of flipping to the pages with the painting that are on the wall in front

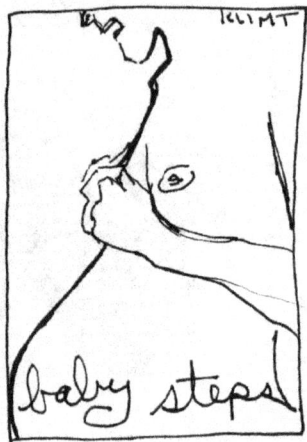
KLIMT
baby steps

February — Opera plays reminding me of Tom. There, in front of me, is the self-portrait, which reminds me of you. Out there is Austria. I feel so unaffected by the self-portrait. I fear the same when I see you.

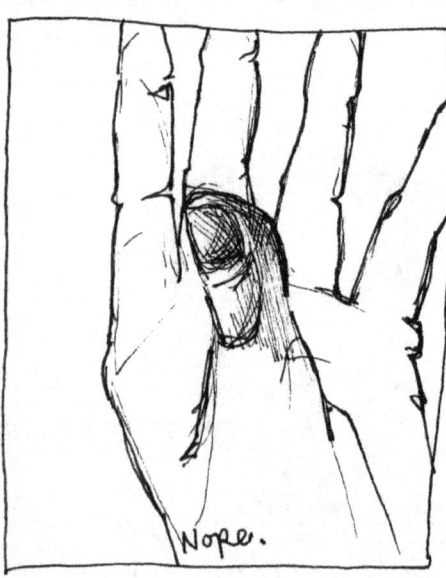
Nope.

of me — blue on left, red on right out of a 293-page book? Seriously? What are the odds? Gerda Leopold: audience 2 - Florentina Pakosta - Paul Sarkisian (Mepleton) 1971/72 - Front Porch - reminds me of Dave Higgins & Chuck Close →

Self Portrait 1971

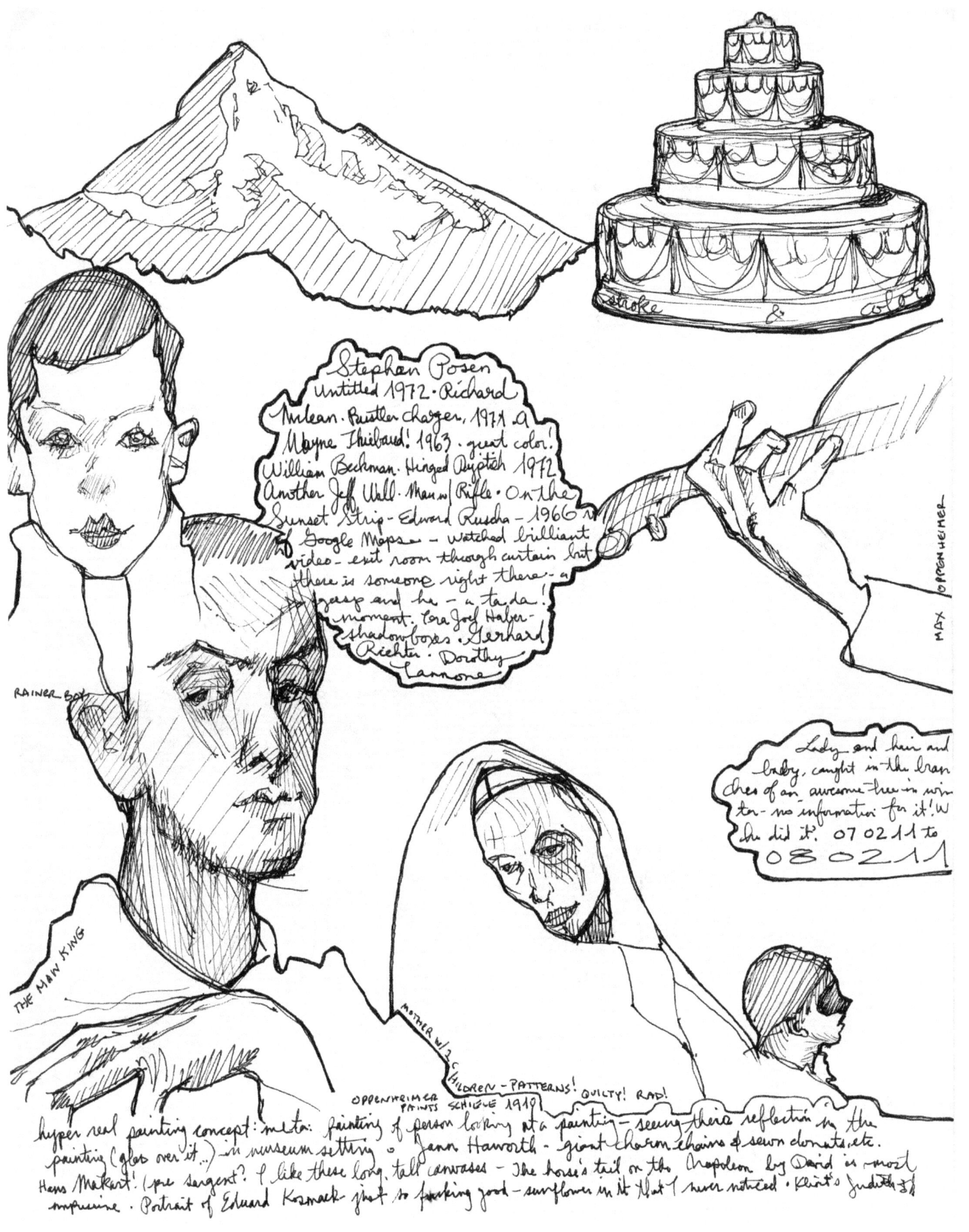

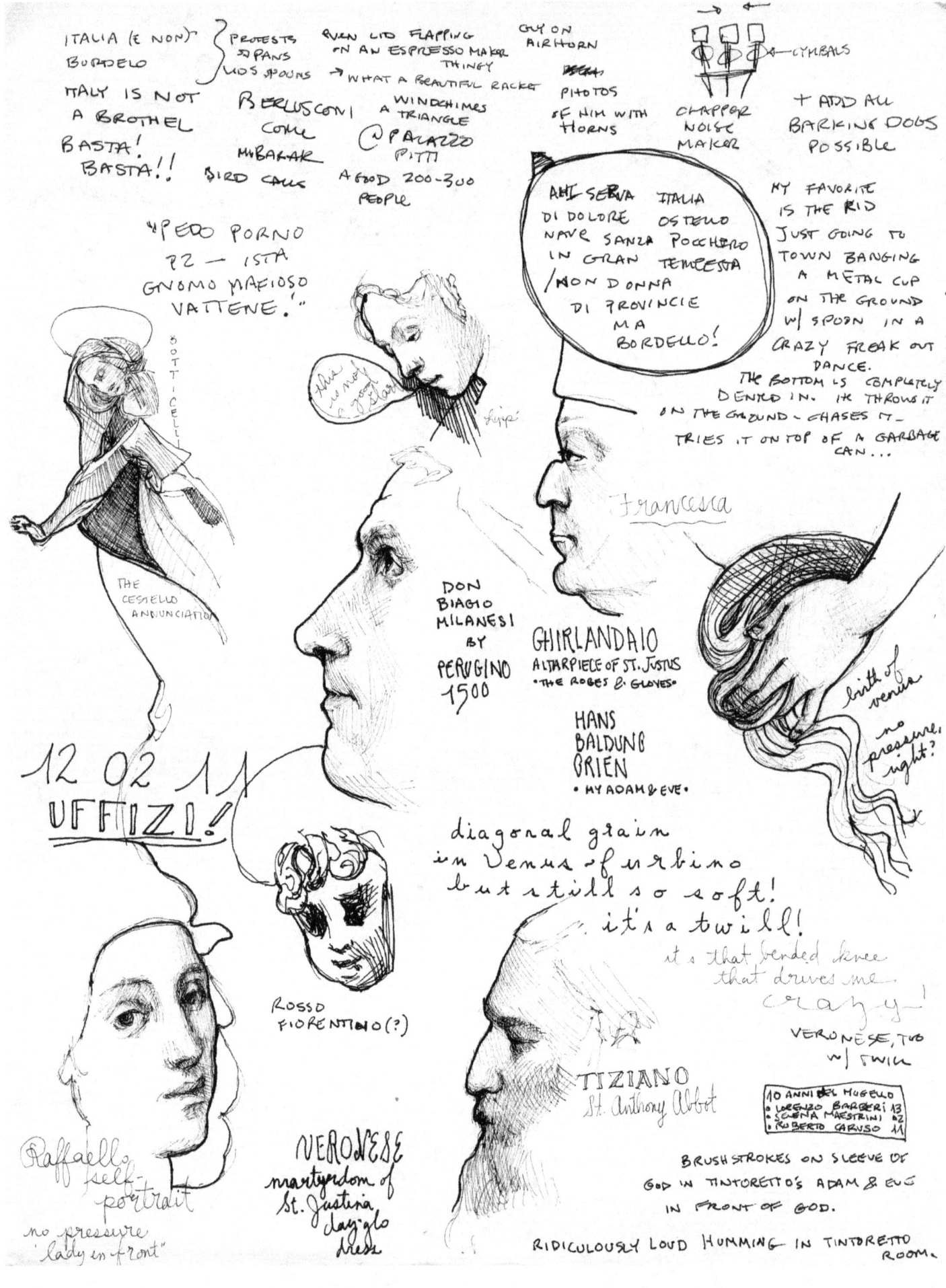

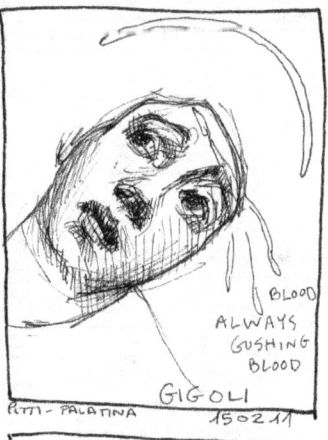
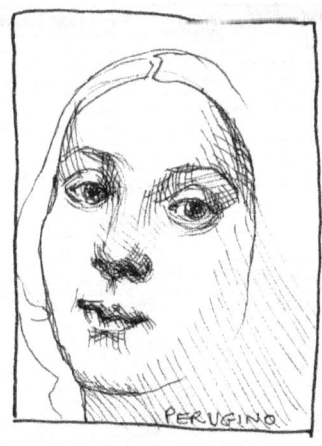
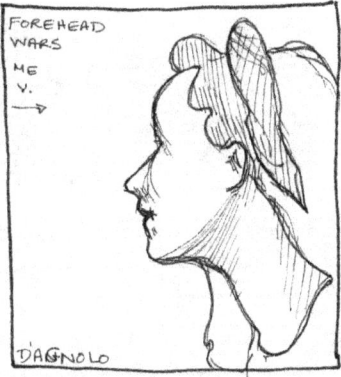
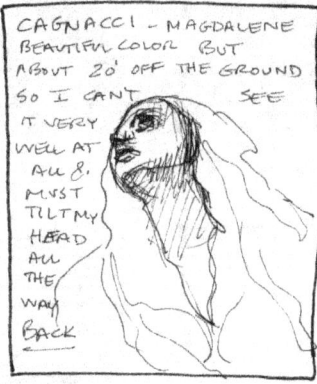
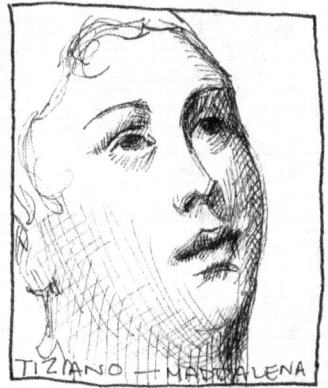

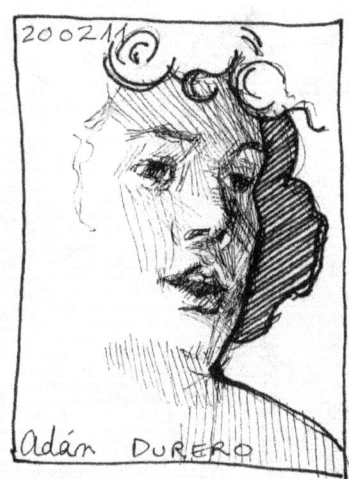

TITIAN: BACANAL - ANDRIOS. WOMAN IN BOTTOM RT CORNER. TINTORETTO: THE ABDUCTION OF HELENA - HELEN'S FACE!! RUBENS CREATION OF THE MILKY WAY. SATURN! VULCAN'S FORGE - VELÁZQUEZ PABLO DE VALLADOLID → MERCURY & ARGOS (10) - GORGEOUS COMPOSITION. REMBRANDT'S JUDITH THE HAND. GOYA: WITCHES' FLIGHT!! JORDAENS OFFERING TO CERES - UN COUP DE DÉS, JAMAIS N'ABOLIRA PAS LE HASARDS - TOUT PENSÉE ÉMETS UN COUP DE DÉS - IDEA: BUILD PORTRAIT COLLAGES IN PHOTOSHOP PROJECT ONTO LARGE CANVASES + TURN INTO WINESTAIN TAPESTRIES COLLAGES TAKEN FROM STILLS FROM VIDEO COLLAGES?! YES HARUN FAROCKI → ÜBERTRAGUNG (TRANSMISSION) - VIDEO 2007 - GODARD - UNE CATASTROPHE

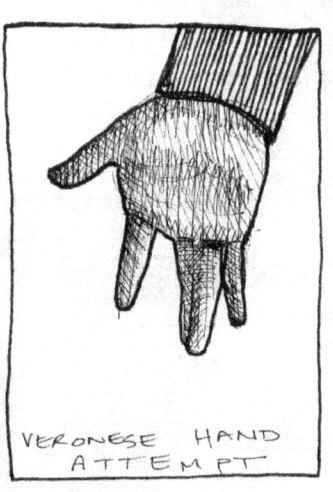
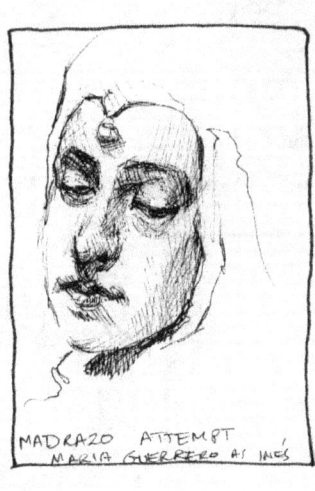

210211 →
"HE WAS AN EVIL MAN, EPOCHAL AND IRRELEVANT AT THE SAME TIME." - WALID RAAD → (ATLAS GROUP) - MISSING LEBANESE WARS #72
GERHARD RICHTER - 48 PORTRAITS
VYACHESLAV AKHUNOV - 1 M²
FRANCESC ABAD: "DAILY JOURNEY"
SOL LEWITT - ON THE WALLS OF THE LOWER EAST SIDE 1976 ——— ALIGHIERO E BOETTI: ENVELOPES TO LUCIANO PISTOI
MEYER SHAPIRO: TRAVEL NOTEBOOKS 1926 ——— A SERIES OF SERIES IS SERIOUSLY SERIOUS • ALFRED STIEGLITZ
FERNAND LÉGER - BALLET MECHANIQUE
I NEVER KNEW DALI DID CUBISM
ROMERO DE TORRES • IGNACIO ZULOAGA CHRIST OF BLOOD
LITTÉRATURE 1919-1924

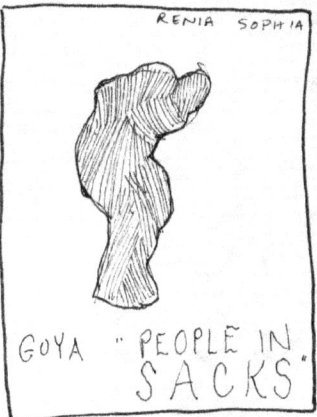
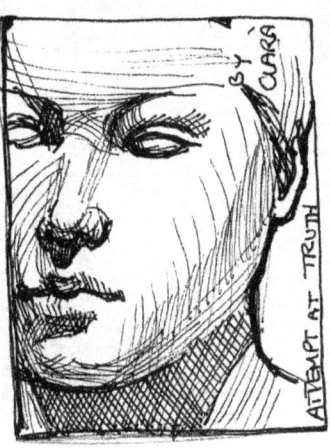
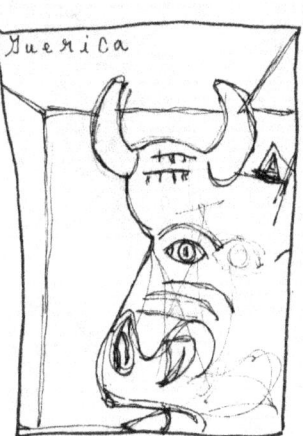

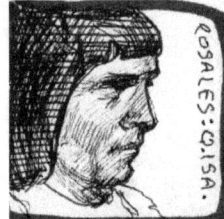
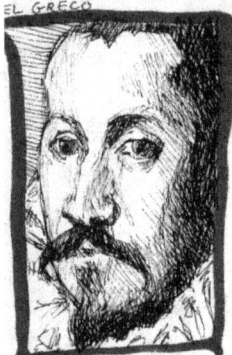
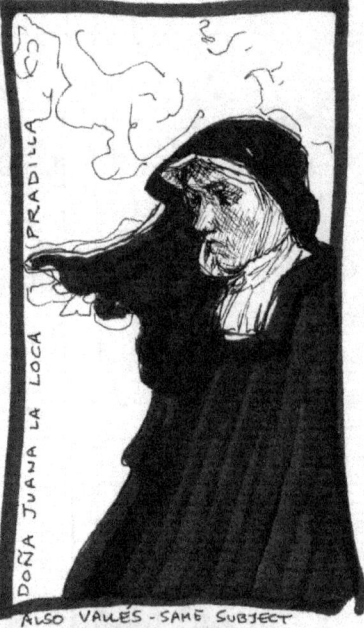
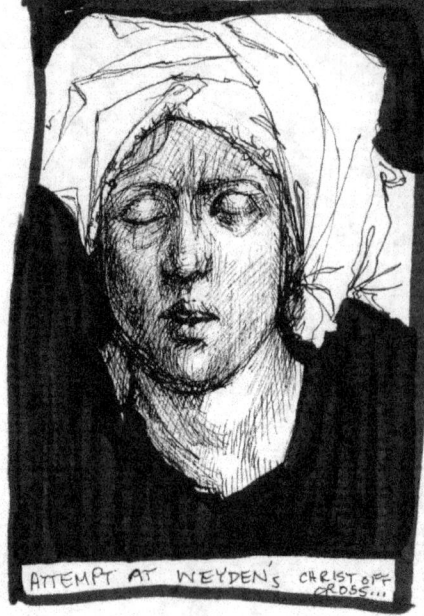

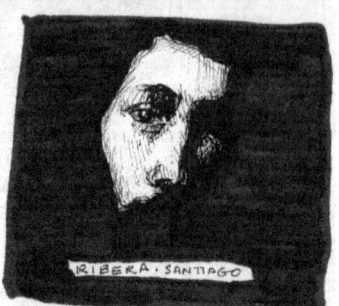
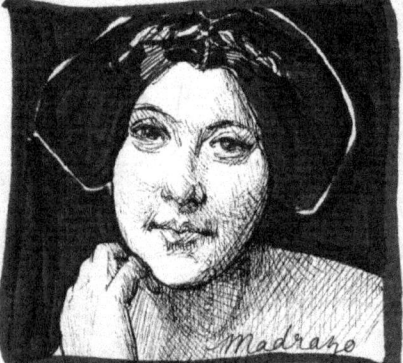

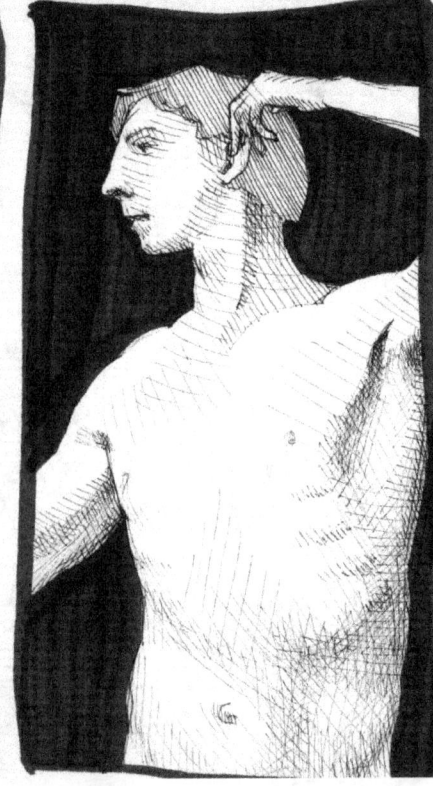
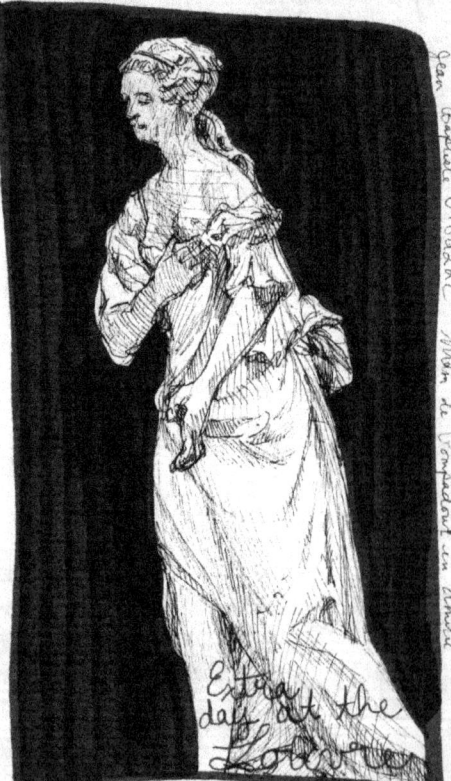
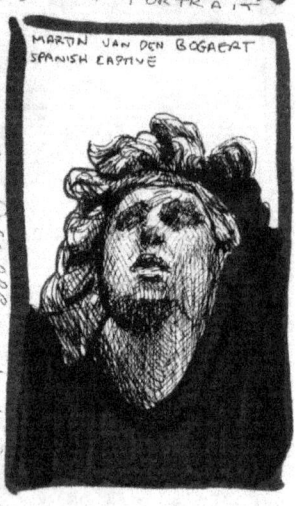

The Grand Museum Count

DECEMBER 14: THE MET ft. STRAND /S___/S___ EXHIBIT OF PHOTOGRAPHY: AUTOCHROME OR RODIN! DECEMBER 20: NEUE GALERIE IN DRESDEN: NEON ARROW W/ ROWS OF CASES OF SCULPTURE IN DARK ROOM. DECEMBER 21: ALTE MEISTER: CANALETTO'S DRESDEN, TITIAN "SLEEPING VENUS." / PORCELAIN MUSEUM: SNUFF MONKEY & BELLS @ 14:15 / ORANGERIE & HERKULES SPECIAL EXHIBIT IN ZWINGER JANUARY 02: ALTE MEISTER MUSEUM AT WILHEMS- HÖHE IN KASSEL: THE REMBRANDTS / NEUE GALERIE: THE SIX-SCREEN SCREAM ORCHESTRA JANUARY 5: CENTRE POMPIDOU ft. MONDRIAN & ARMAN (SUITCASE OF BOY DOLLS) & FEMME ART (CELLO ECHO). JANUARY 6: MUSÉE D'ORSAY ft. GÉRÔME (RAM LADY) ALSO ENJOYED THE SCULPTURE OF DENYS PUECH. JANUARY 7: MUSÉE DE LOUVRE ft. PATRICE CHÉREAU CURATION OF BODIES- VERY LOVELY BLEND OF WORK, DAVID'S MARAT MADE ME CRY. JANUARY 8: GUSTAVE MOREAU'S STUDIO - WONDERFUL TO BE ABLE TO REALLY SIT WITH WORK. I MUST DRAW 800x'S WHAT I DO NOW! PROLIFIC! ART FACTORY! JANUARY 10: DELACROIX MUSEUM: SMALL & I MADE A FOOL OF MYSELF, BUT LOVELY TO SEE THE ATELIER. JANUARY 11: SAINTE CHAPELLE: JESUS CHRIST AWESOME- ONE OF THE MOST KICK ASS PLACES EVER; CONCIERGERIE: STRANGE MOVIES IN FRANCE EXHIBIT & MARIE ANTOINETTE'S CELL; RODIN: A LOT OUTSIDE & INACCESSIBLE (RE-LANDSCAPING). STRANGE SQUEEKY INDOOR EXHIBIT AREA- AWESOME. JANUARY 12: LOUVRE - CONTINUED RICHELIEU - 2ND FLOOR & STARTED THE MONALISA SECTION BUT THOUGHT IT WISE TO RETURN LATER JANUARY 13: LOUVRE - DENON JANUARY 14: GUIMET- COULDN'T FIND "THE WAVE" & DIDN'T REALLY PRESS - LOVELY MUSEUM LEFT A TREASURE MAP IN THE LIBRARY, QUAI BRANLY - EXCELLENT COLLECTION & MARVELLOUS PRESENTATION JANUARY 16: ARTS ET MÉTIERS - A LITTLE OVERWHELMING AT THE TIME- WISHED WHITNEY WAS THERE - NICE DISPLAY ON CORNING & FIBER OPTICS! JANUARY 25- HET VALKHOF IN NIJMEGEN -- REALLY STRANGE LAYOUT - STAIRS EVERYWHERE JANUARY 27 - FOTO MUSEUM DEN HAAG: CECILY BROWN PHOTO COMPETITION & POLAROIDS - NICE; MAURITHUIS - GIRL W/ PEARL EARRING - ABSOLUTELY WONDERFUL- SPENT A PERFECT AFTERNOON & A GOOD HOUR STARING AT HER! JANUARY 28 - PANORAMA - BY MESDAG - STUNNING ESPECIALLY AFTER VISITING THAT SPOT EARLIER IN THE MORNING, NOT KNOWING IT WAS IN THE PANORAMA!! JANUARY 29: RIJKSMUSEUM: NIGHT WATCH! MADE ME WANT TO BE IN LOVE, ODDLY.; VAN GOGH MUSEUM - SURPRISING NICE PIECES THAT ARE LOVELY *!! FORGOT TWO! JANUARY 26 - SPEELKLOK: BEIJING TREASURES - AWESOME & ABORIGINAL ART: UMM... OK. JANUARY 30: FOAM (PHOTOGRAPHY) - HIGHSCHOOL MEMORY; VAN LOON HOUSE - CRAZY FEBRUARY 1: ALTE NATIONALGALERIE BERLIN - SO HUNGRY AND BARELY STANDING & HISTORICAL MUSEUM FEBRUARY 2: GEMÄLDEGALERIE IN BERLIN! GOOD COLLECTION, SCARY QUIET - NECK HURT BADLY SO NO SKETCHING & LOTS OF PAUSES - STRANGE TASTE LEFT IN MY MOUTH FROM THAT MUSEUM COMPLEX FEBRUARY 3: HAMBURGER BAHNHOF - I WILL VIVIDLY REMEMBER HATING IT, WITHOUT A DOUBT; THE PHOTO- GRAPHY MUSEUM - HELMUT NEWTON EXHIBIT THAT GOES WELL WITH THE 90'S EXHIBIT AT FRANKFURT WITH SAME SENTIMENTS ON MY BEHALF; FEBRUARY 6: LEOPOLD IN VIENNA: OBVIOUSLY MEMORABLE - APPARENTLY I LIKE KOLOMAN MOSER. FEBRUARY 7: MUMOK - HYPER REAL SHOW - OUTSTANDING SHOW - GREAT MIXTURE OF PIECES - VIDEO PIECE W/ AUDIENCE & DE LA TOUR GAMBLING SCENE & RED SILK BLOOD - AWESOME & KUNST HALLE W/ FEMALE POP ART - LIKED DOROTHY IANNONE & JAN HAYNORTH BUT LARGELY A BIT MUCH..... FEBRUARY 8: BELVEDERE: POORLY LIT, GOOD COLLECTION, THE EMBRACE MADE ME CRY; SECESSION: SCROLL OF LONG BEACH, INSTALLATION & PHOTOGRAPHY - NICE PEOPLE WORK THERE - KLIMT KICKS ASS; KHM - WHOA CRAZY BUILDING IN AND OF ITSELF - GOOD BODY OF PAINTINGS, CARAVAGGIO, TITIAN, DÜRER, RUBENS, DYCK & WONDERFUL SET OF 5 MARGARITA TERESAS BY VELÁZQUEZ! FEBRUARY 10: MUSÉE DE L'ART BRUT: POWERFUL STUFF - DIMLY LIT SO MY EYES REALLY HURT TOWARDS THE END - MADE ME HATE CURRENT PRETENTIOUS KINDERGARTEN STYLE EVEN MORE - THESE PEOPLE COULDN'T CHOOSE TO DO IT TO BE COOL!! FEBRUARY 12: UFFIZI - LESS THAN I EXPECTED - OBLIGATORY 1 HOUR WAIT IN LINE - VENUS OF URBINO WAS ABSOLUTELY STUNNING FEBRUARY 13: MUSEO OPERA DUOMO - "WOODEN MAGDELENE BY DONATELLO - SO UGLY! NICE PEOPLE THERE; PALACE VECCHIO - WEIRD - LOTS OF CRAZY ROOMS - FELT VERY EMPTY - SAW DAMIEN HIRST DIAMOND ENCRUSTED SKULL - RIDICULOUS / FEBRUARY 14: BASILICA SAINT STEFANO - MARY'S BELT RELIQUARY &

LIPPI FRESCOES W/ LANA - SHE MANAGED TO GET US IN AFTER ALL WAS CLOSED/LIGHTS OFF - AMAZING! FEBRUARY 15: PALACE PITTI: TERRIBLE LIGHTING - LOTS OF COPIES OR SECOND RATE EXCEPT TITIAN'S MAG- DELINE - WAS SO HUNGRY COULDN'T GO ON - IMPRESSIVE ROOMS, CHANDELIERS & CEILINGS - FEBRUARY 17: BAYONNE - MUSEUM OF NOW IN THE MAIN CATHEDRAL THERE - WALKED IN & THE COMBINATION OF STAINED GLASS, MONKS SINGING ON SOME DISTANT SPEAKER & CHURCH BELLS MADE ME CRY - FEBRUARY 19: ARCO - ENDLESS & INTENSE & HAD ONE REALLY GREAT PAINTING OF MAN & CELLPHONE FEBRUARY 20: PRADO NEED I SAY MORE? 5 HOURS NOT NEARLY ENOUGH. GOYA, VELAZQUEZ, TIZIAN, ADAM REVE DÜRER, MAD- RAZO FEBRUARY 21: REINA SOFIA: THOUGHT IT WOULD BE SMALL & WAS HORRIBLY MISTAKEN GUERNICA & LOVELY SERIES OF SERIES CALLED 'ATLAS'. FEBRUARY 22: PRADO AGAIN - LOTS OF DISCOVERY OF SPANISH PAINTERS FROM 18TH & 19TH CENT. BOSCO IS CRAZY! FEBRUARY 20-22: MUSEO DEL JAMON - THE AWESOME BREAKFAST PLACE. FUCKING LEGIT. FEBRUARY MARCH 01: SAGRADA FAMILIA - MUSEUM ABOUT GAUDI & HIS GEOMETRY OF NATURE & HOW IT FACTORED IN - RIDICULOUSLY AWESOME AS JESUS HOLY GOD JESUS. MARCH 02: EXTRA TIME AT THE LOUVRE! CRANACH TEMP EXHIBIT

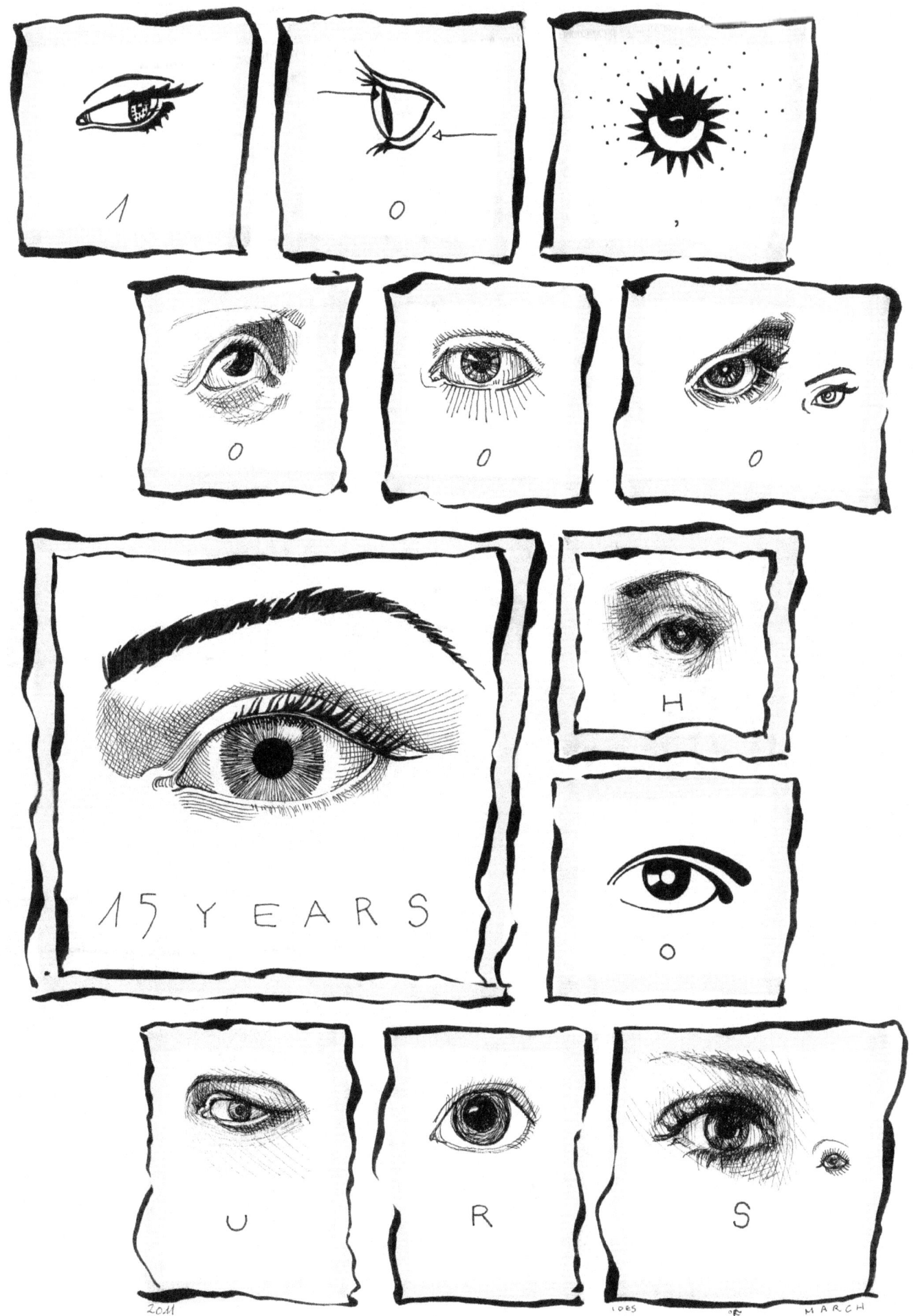

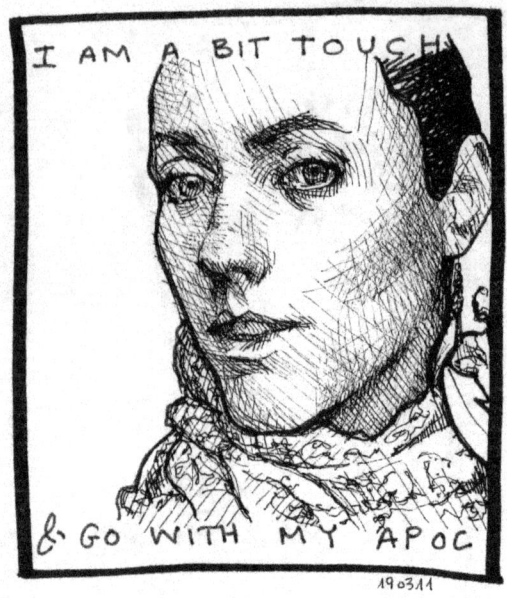
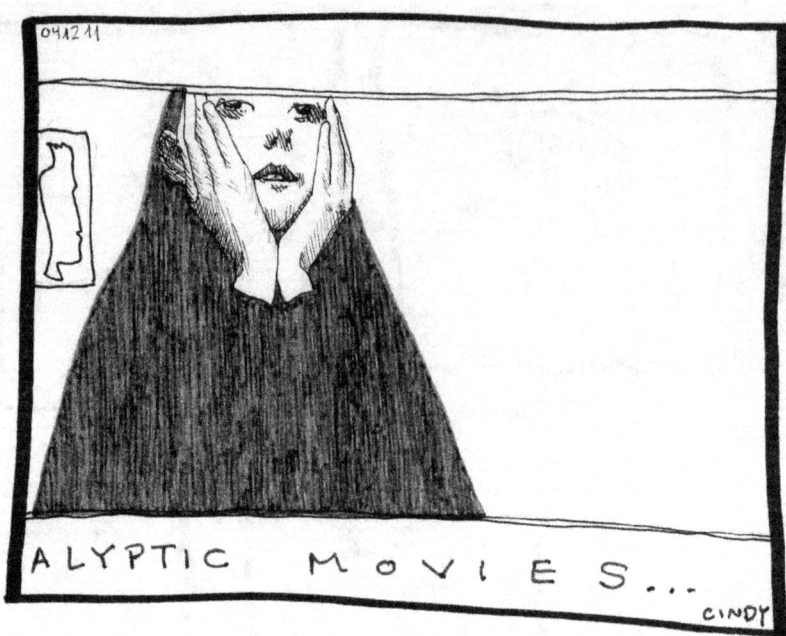
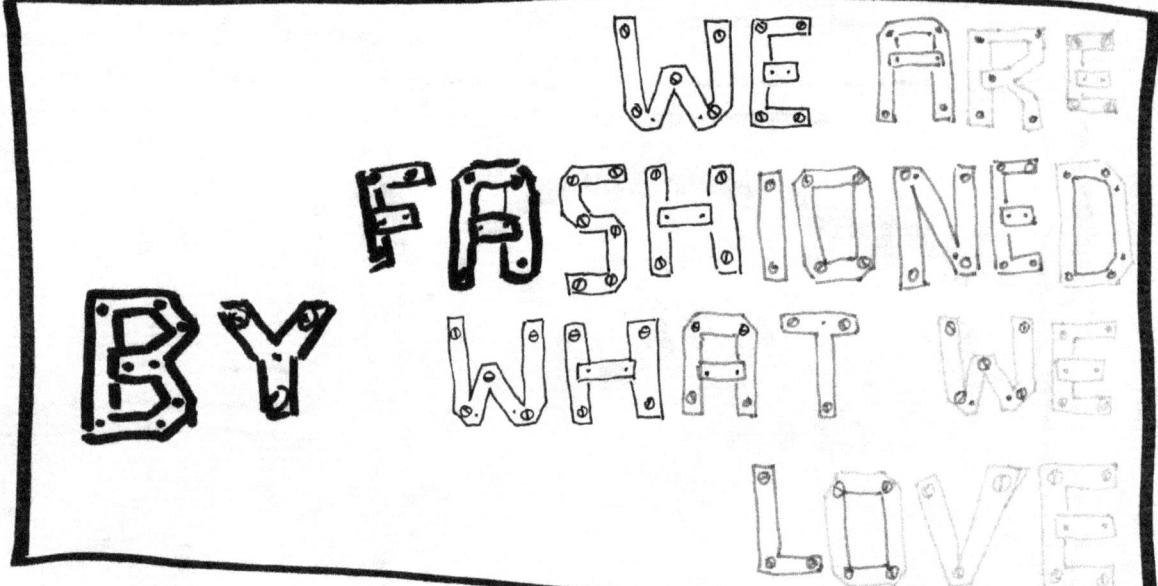
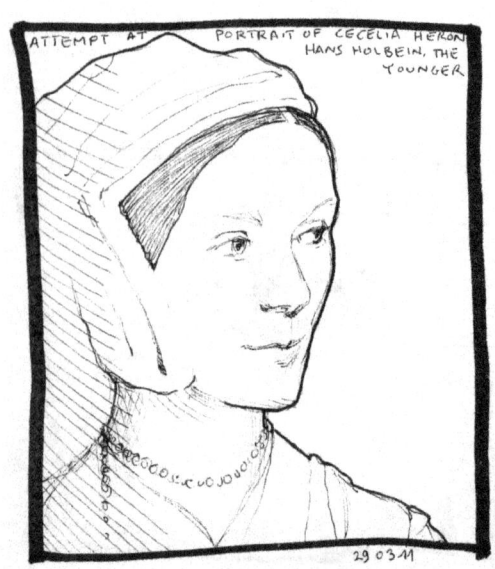
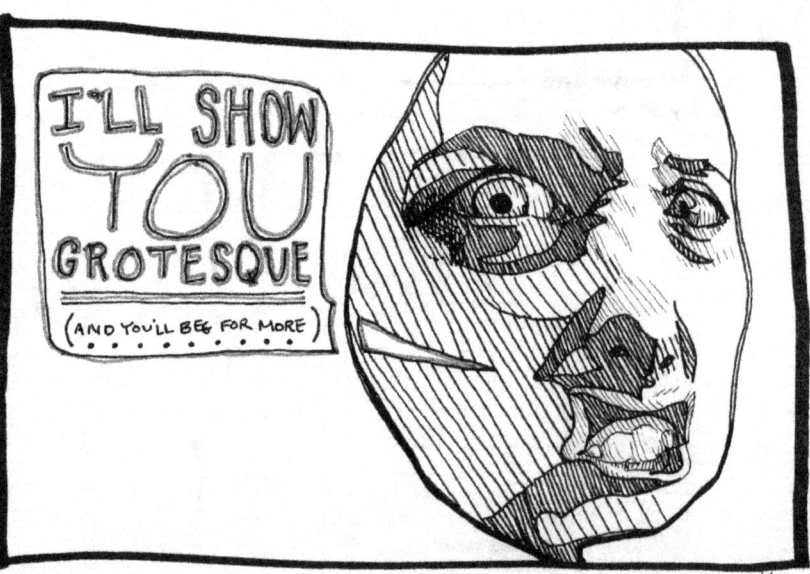

04.12.11

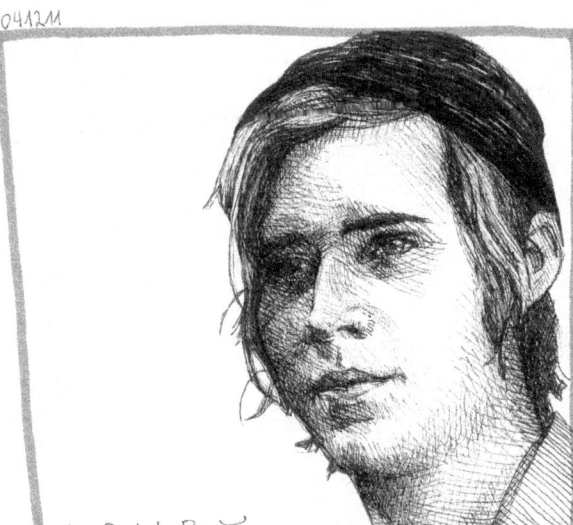

ASHBY

Memorial Day. I can count four orioles in the willow tree where I once watched Caitlin climb up as her father encouraged her and advised. I wanted to climb, too, but I was little and it has always been my nature to be timid at first. There is a chipmunk at my back — and a giant black ant on my toes. I have now had a second night of poor sleep because of my wondering mind — a red wing black bird calls — I swear I heard a bobolink. Everyone is napping inside. There are snap dragons growing through the steps on which I sit somewhat uncomfortably. I am trying to draw dandelions puffs and other stuff... I finally hear snoring from a nearby napper. I am staring and with the light breeze, my eyes are drying out and forcing me to blink hard. I am very interested to see you again on Thursday. I have this feeling that we are both being extra delicate about what we say to each other just yet. The toads & frogs throat thump at each other strumming their tight bass twang throat strings. The jazz organ slide bang of the red wing added in makes me shiver a little. This is all important — all of it.

bisous

JAS

HELLO my name is

PROFESSOR

103/150 J. and

"STOP SUCKING ON ME..." 05.13.11

LAP

SAME FELLOW, RUNNING LAPS UP AND DOWN MARKET STREET — DIFFERENT SHOES 2 HOURS LATER. 05.22.11

BLUE WOODEN RIBBONS, WHITE SEQUIN DRESS, BLUE NEON WIRE, WET FEET, NIGHT WALK ALONG THE RIVER, SWEET SWEET RELIEF
05.27.11

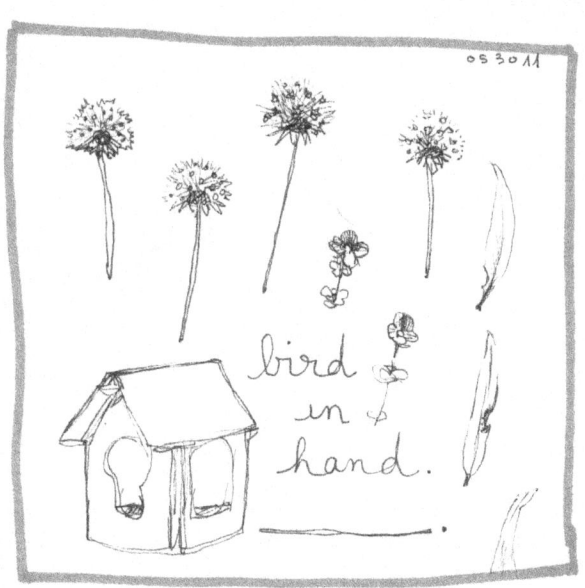

05.30.11

bird in hand.

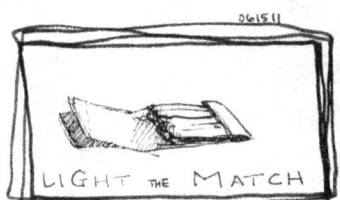
LIGHT the MATCH

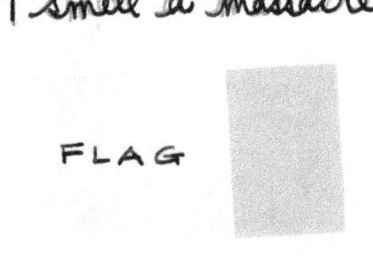
I smell a massacre.
FLAG

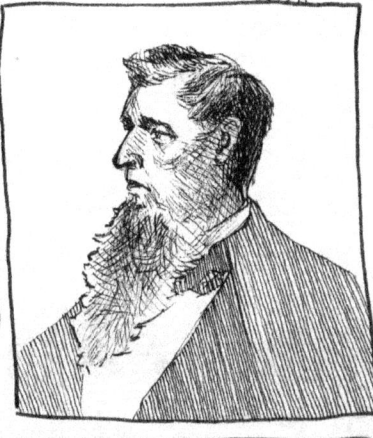

"DIVINE PUNISHMENT"
"CRUDO"
"TA DHA CINN ORM"
"THERE ARE 2 HEADS ON ME"
"FUR-TONGUED"
"SQUINTED"
"WEARING LOUD SHOES"
"DAWN DAMAGE"
"TØMMERMÆND"
"HYPEROSMOLAR"
080611

SHOREWOOD YOU MAKE MY DREAMS COME TRUE
THE OLD WOMEN LAUGH THEMSELVES SICK BECAUSE THEY KNOW HE HASN'T A BEAN (GOYA)

PSSSST.. HEY OVER THERE EZRA CORNELL

Caution!
APOLLO IRS.
NOW YOU KNOW THE Difference!!!

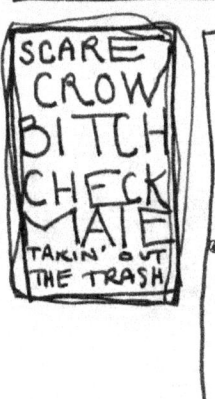
SCARE CROW BITCH CHECK MATE TAKIN' OUT THE TRASH

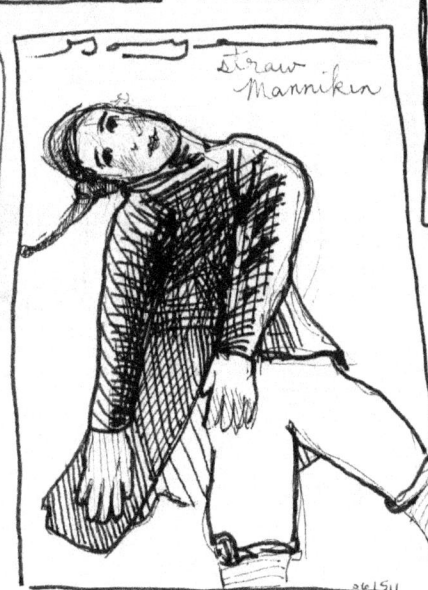
straw Mannikin

FLAG
Qi Xi Day

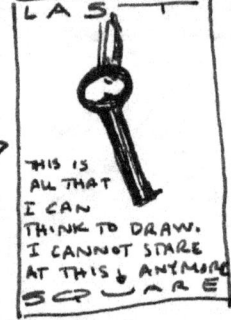

DONNA JUST REMEMBERED MY USUAL. THIS MAKES ME UNBELIEVABLY HAPPY. SINCE I LAST OPENED TO THIS PAGE: WE HAD THE FRINGE OF A HURRICANE (IRENE), A TROPICAL STORM (LEE), WHICH IS CAUSING FLOODING TOWARDS BINGHAMTON, I MET A PHYSICIST, AN ASTRONOMER & CRASHED A WEDDING AND CONFIRMED A GOLDEN AGAPE 0908M↗

LILLY MARTIN SPENCER: PEELING ONIONS 1852
HOMER: ARTIST'S STUDIO IN AFTERNOON FOG 1894
PARRISH: UNDERPAINTING IS VERY ORANGEY BROWN - ALMOST TIE-DYE LOOKING & BUILT UP FROM THERE. VERY HAZY & SUPER THIN → FACES, HAIR & CLOTH - LEAF PATTERNS ARE INSANE.
JOHN TAYLOR ARMS: LIMOGES THE REFLECTION IN THE W A T E R
PAUL MCKINLEY: BATH
JEFF KELL: RUST! "BUNG"
KIM WAALE: MANLIUS

HT COOGAN'S SPINNING EDUCATIONAL TURNTABLE OF SHIFTING ATTRACTIONS AND INCONSISTENT DIRECTION.
"MY MOUTH TASTES LIKE ASS!" BEAVERBOARD - AMERICAN GOTHIC
I DREW MORE TODAY = BARGUE PLATE NO. 1. AGAIN - DREW BADRE, RACHEL & KAT YESTERDAY. BUT I SORELY NEED TO ATTEND TO MY FINANCES... MAKE TO-DO LISTS.

À REBOURSE. LEAVES OF GRASS. JITTERBUG PERFUME. GRAMMAIRE FRANÇAIS. TO-DO L I S T S

LEITMOTIF

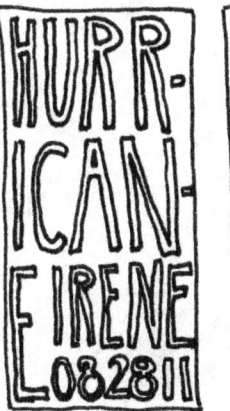

HURRICANE IRENE 082811

wispy

willowy

Quality Logs Addison, NY

BEEN AWHILE YES?!
AMELIA?

Donna's Restaurant "I don't know why I ordered a BLT! I wanted a tuna on rye!!" 082311
THE BIG QUAKE OF '11!
(GOT TO REFER TO "I REMEMBER A TIME IN LATE '98 WHEN EVERYTHING WAS SHAKIN'"

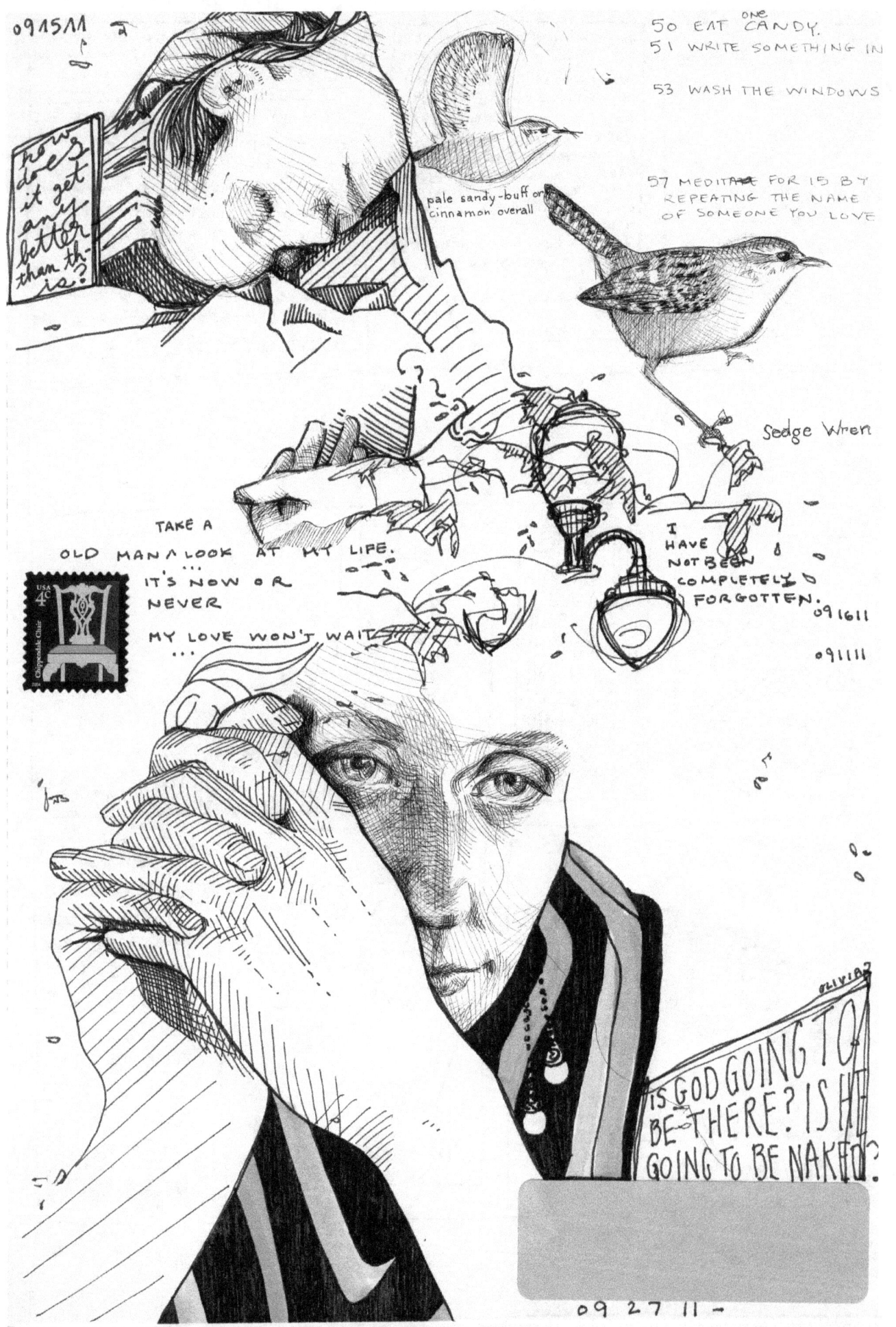

Command F1 to project

SUBBING FOR POLLY

Detailed description of contents (1)	Qty. (2)	Weight (3) lb.	oz.	Value (4) (US $)	HS Tariff # (5)
MY HEART 🎩	1		9	72K	—
MY HANDS	2		13	72K	—
MY HEAD	1	9	2	72K	—

Sender's Signature and Date (8)
SEPTEMBER 16, 2011

Detailed description of contents (1)	Qty. (2)	Weight (3) lb.	oz.	Value (4) (US $)	HS Tariff # (5)
RIDE THE	T	I	G	E	R
YOU ARE THE	D	R	I	VE	R
YOU OWN THE	R	O	A	D.	-DIO

Sender's Signature and Date (8)
SEPTEMBER 24, 2011 VIA ✍

09 29 11

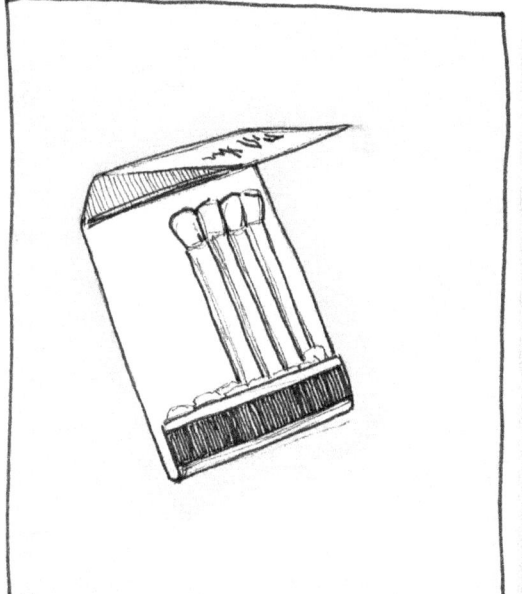

Detailed description of contents (1)	Qty. (2)	Weight (3) lb.	oz.	Value (4) (US $)	HS Tariff # (5)
IS IT					
3.33?			.33?		
OR					
		O	VER		
		H	EAR	D	
		ON	MAR	KE	T
		MS	T	RE	ET

Sender's Signature and Date (8)
SEPTEMBER 27, 2011

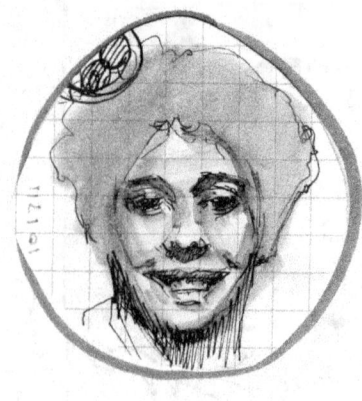

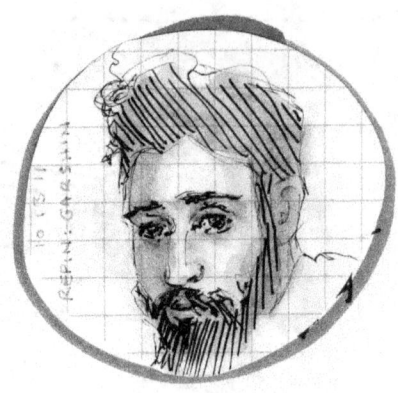

11
YOU DO NOT HAVE TO BE GOOD. YOU DO NOT HAVE TO WALK ON YOUR KNEES FOR A HUNDRED MILES THROUGH THE DESERT REPENTING. YOU ONLY HAVE TO LET THE SOFT ANIMAL OF YOUR BODY LOVE WHAT IT LOVES. TELL ME ABOUT YOUR DESPAIR, YOURS, AND I WILL TELL YOU MINE. MEANWHILE THE WORLD GOES ON. MEANWHILE THE SUN

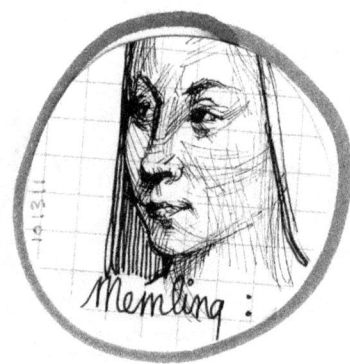

Memling :

23
AND THE CLEAR PEBBLES OF THE RAIN ARE MOVING ACROSS THE LANDSCAPES, OVER THE PRAIRIES AND THE DEEP TREES, THE MOUNTAINS AND THE RIVERS. MEANWHILE, THE WILD GEESE, HIGH IN THE CLEAN BLUE AIR ARE HEADING HOME AGAIN. WHOEVER YOU ARE, NO MATTER HOW LONELY,

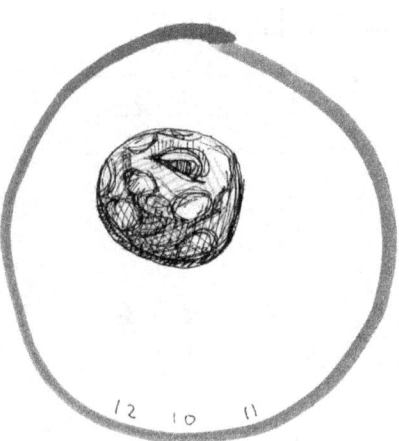

11
THE WORLD OFFERS ITSELF TO YOUR IMAGINATION, CALLS TO YOU LIKE THE WILD GEESE, HARSH AND EXCITING — OVER AND OVER — ANNOUNCING YOUR PLACE IN THE FAMILY OF THINGS.
— MARY OLIVER

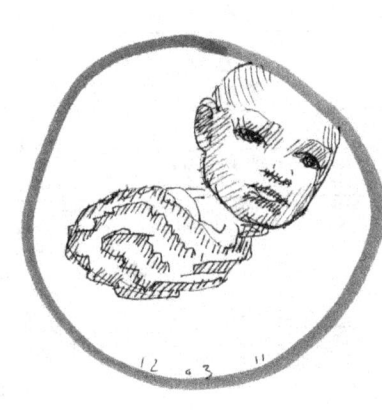

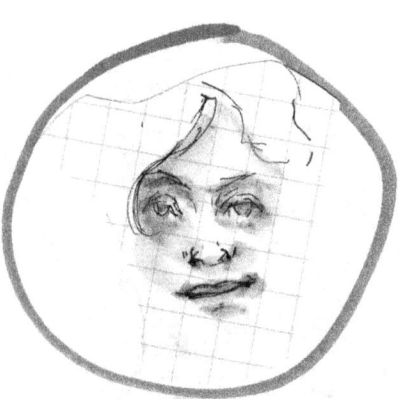

THE SOFTEST PIPSQUEAK EVER

YARN MYSTERY BOX

MADE WITH BABY!

12 03 11

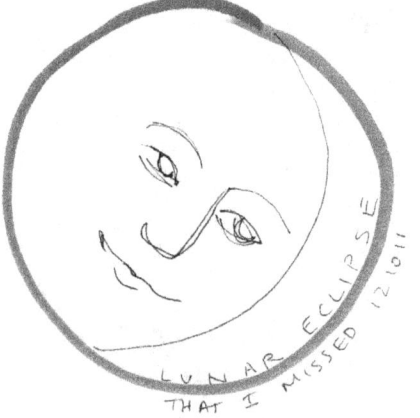

LUNAR ECLIPSE THAT I MISSED 12.10.11

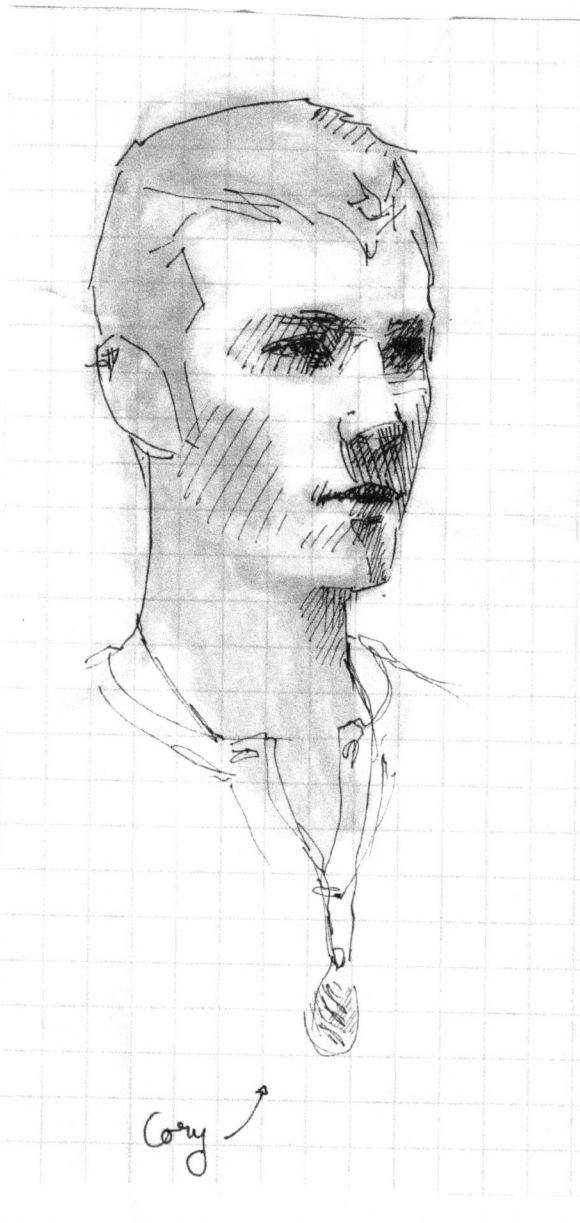

Cory

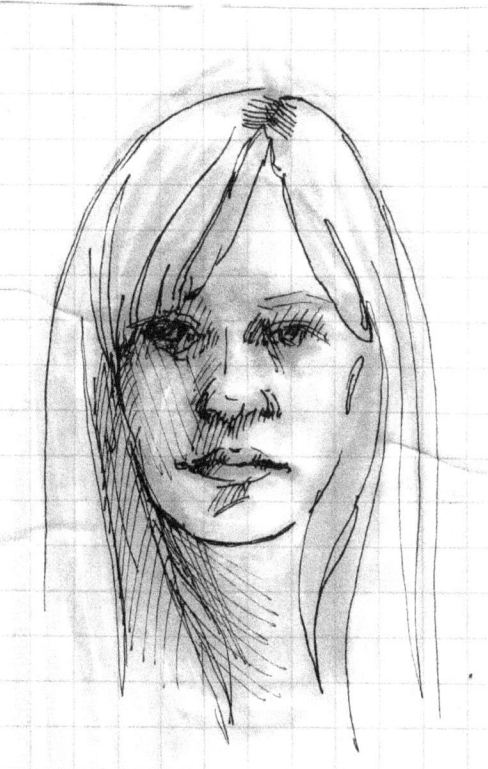

Claire 10·24
Drawing II substituting

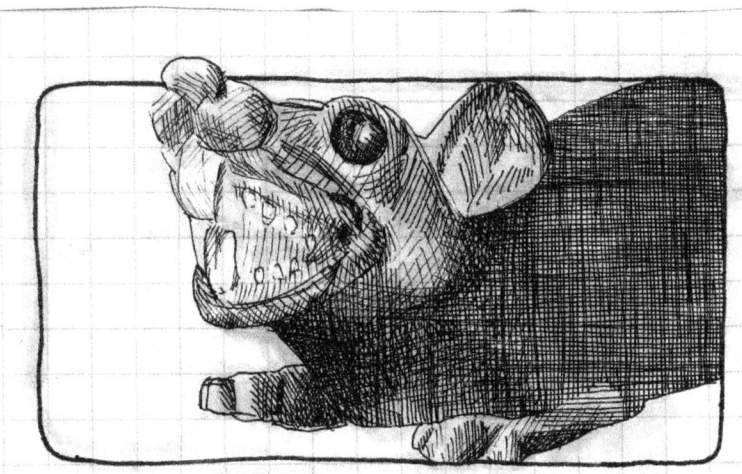

Rat in Pepsi vending machine
10-25

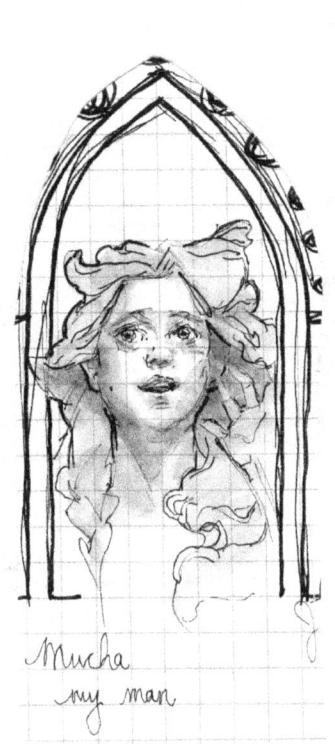

Mucha
my man

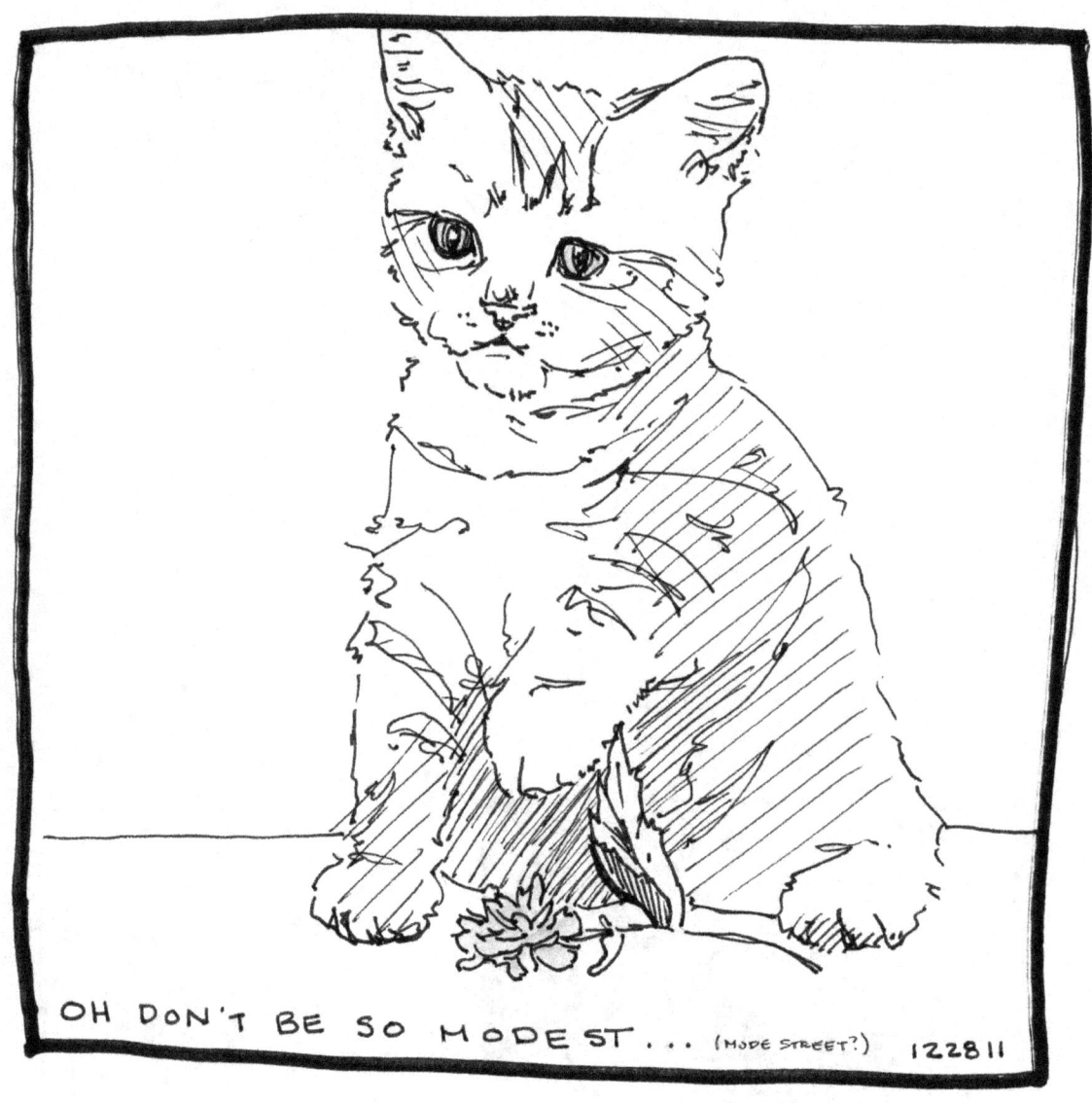

8

49

10

51

[oh my!]

020212
fun with
free hand
52 card
psycho

[by G.A. RHODES]

52

6

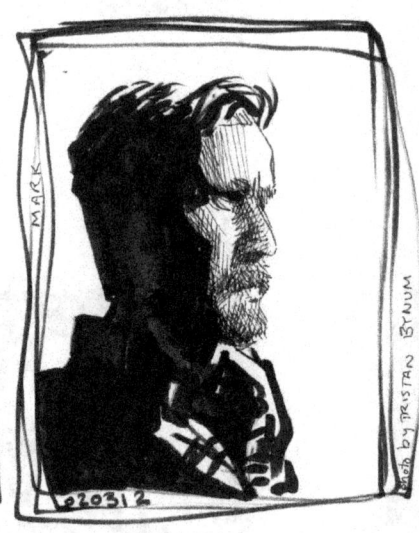
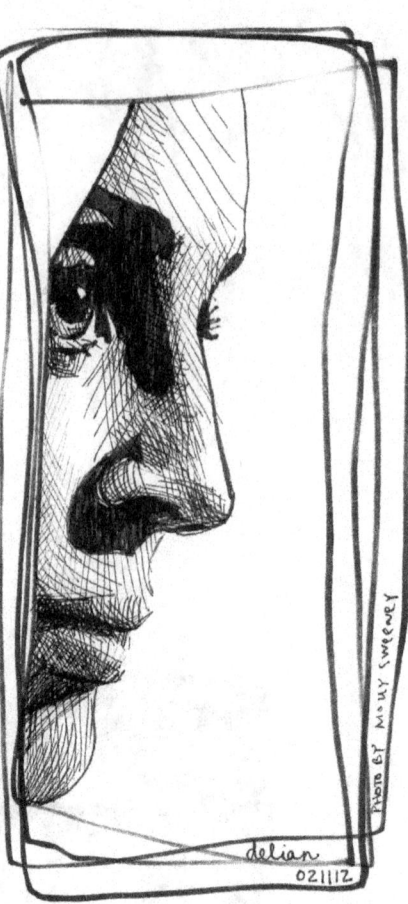

every time someone sings, drink; every time someone is crying, drink; every time someone is crying while singing, drink it *all*.

I was there in a paper cup.

I am still finding sawdust on my person.

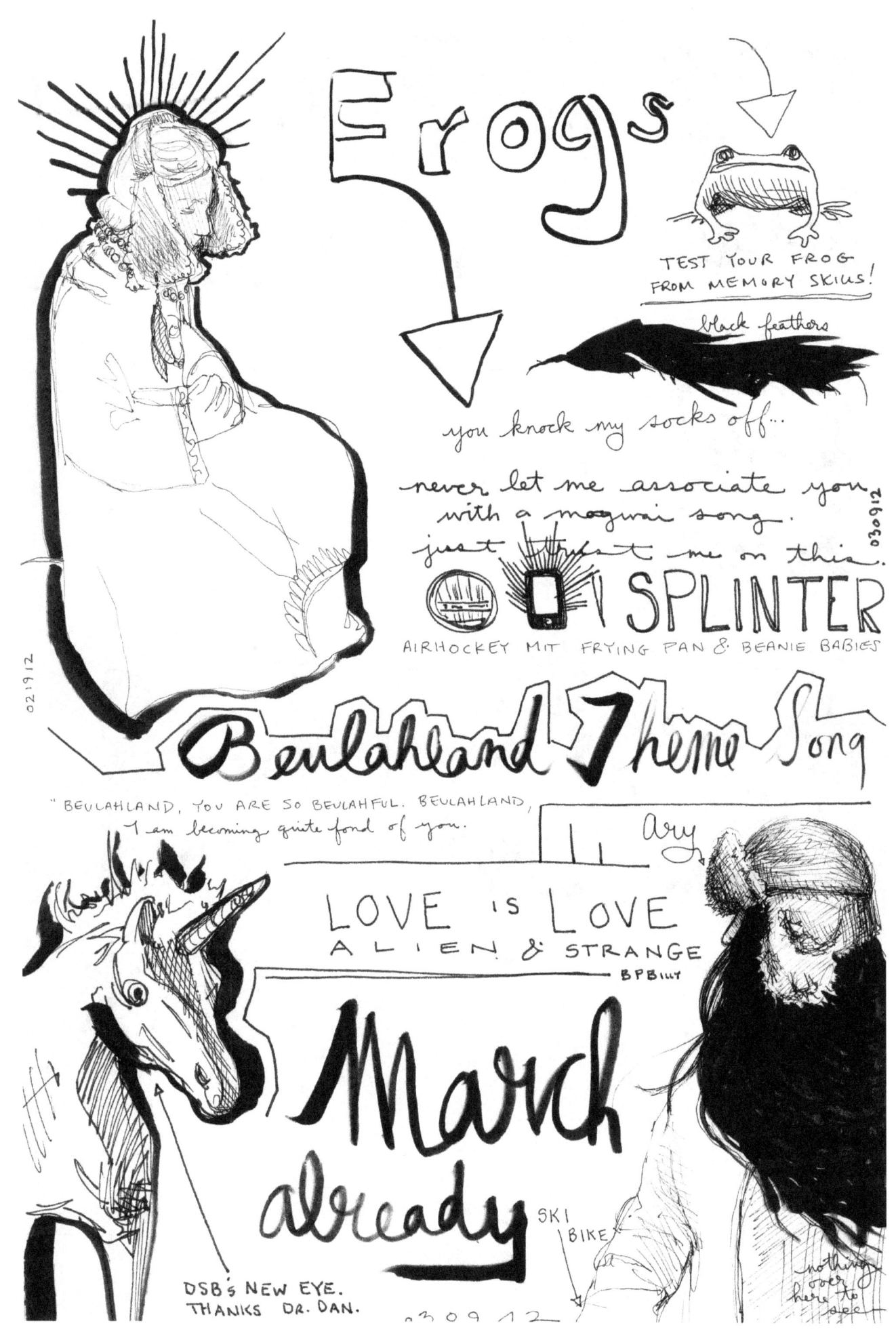

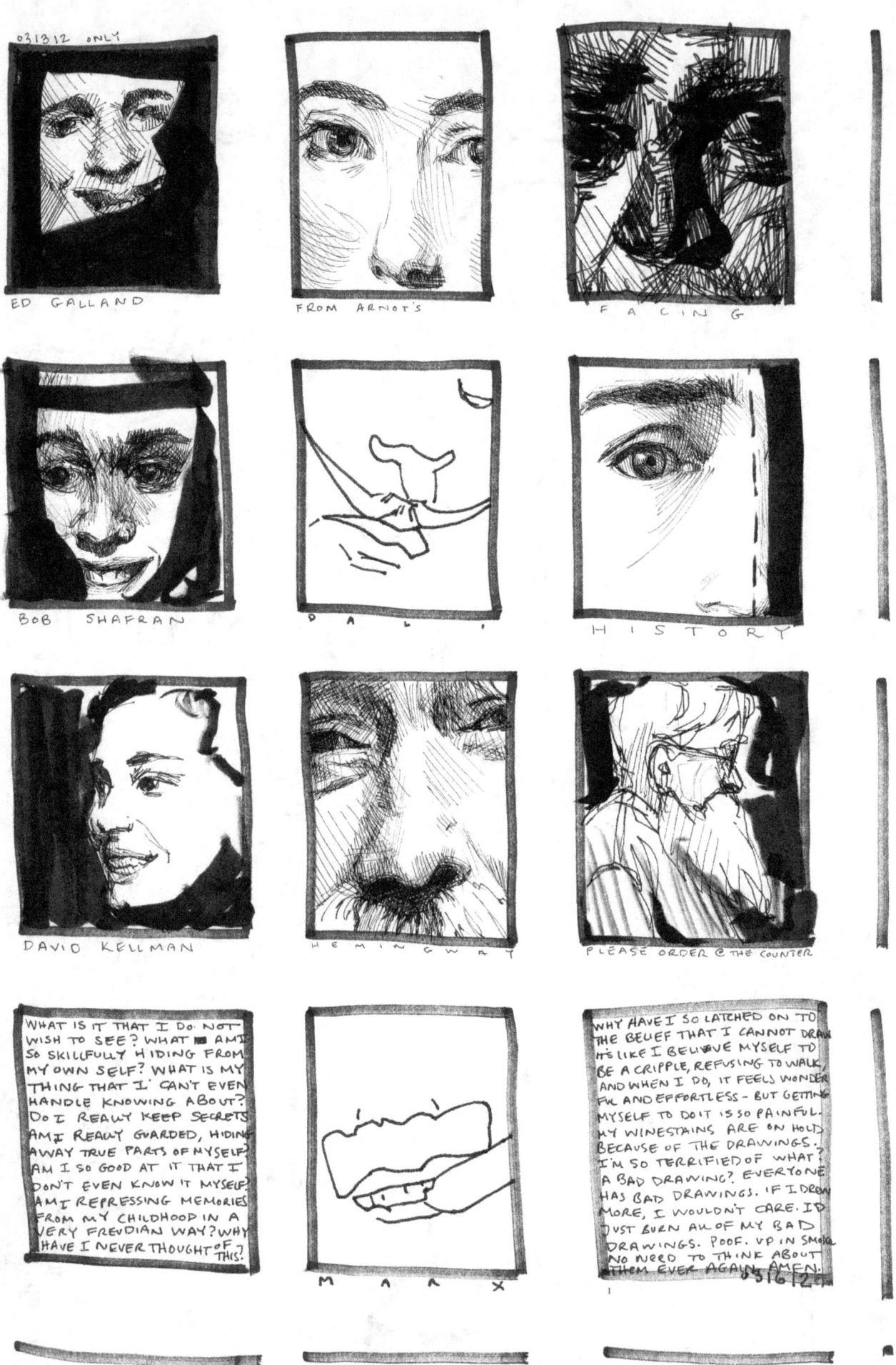

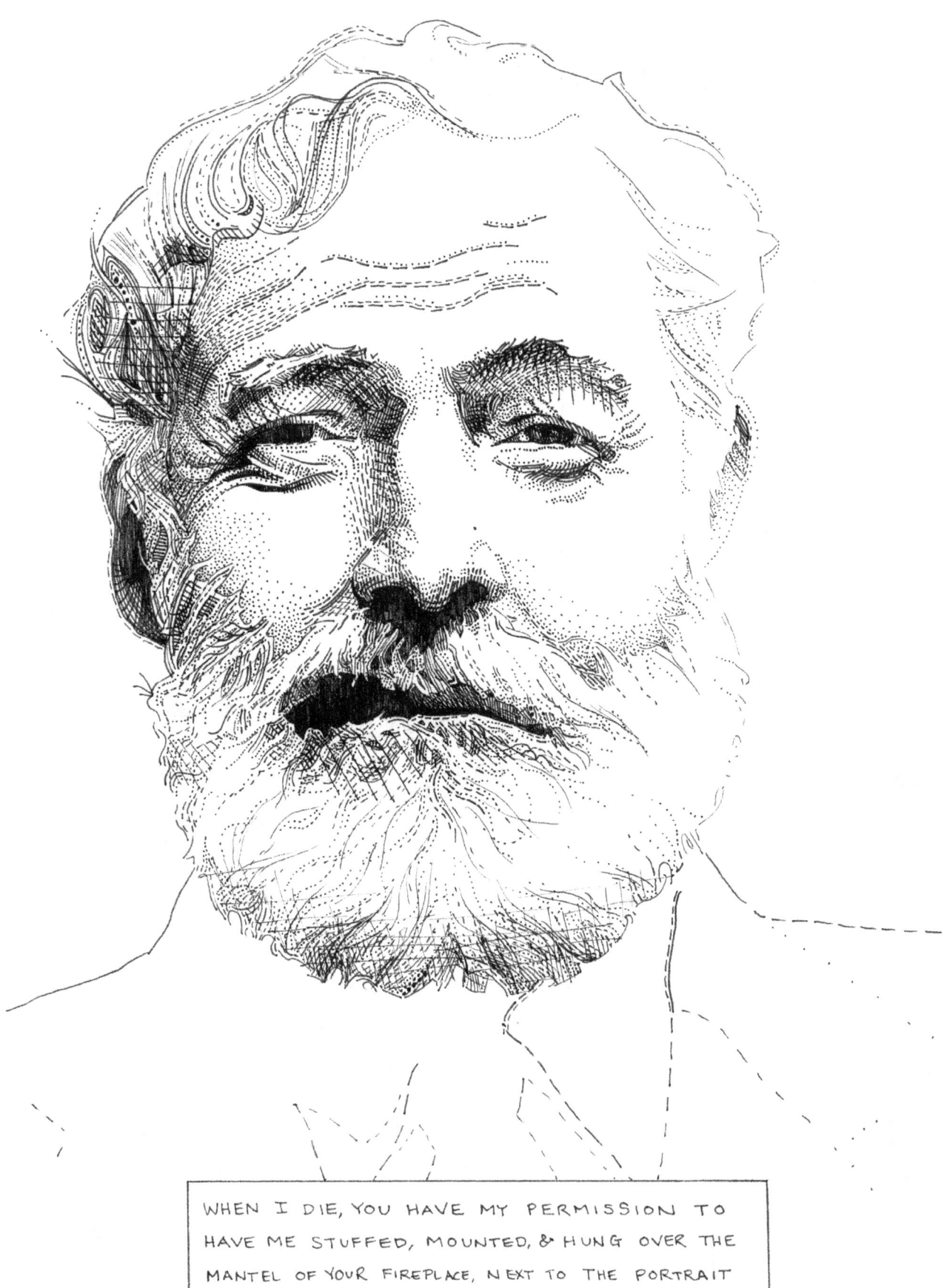

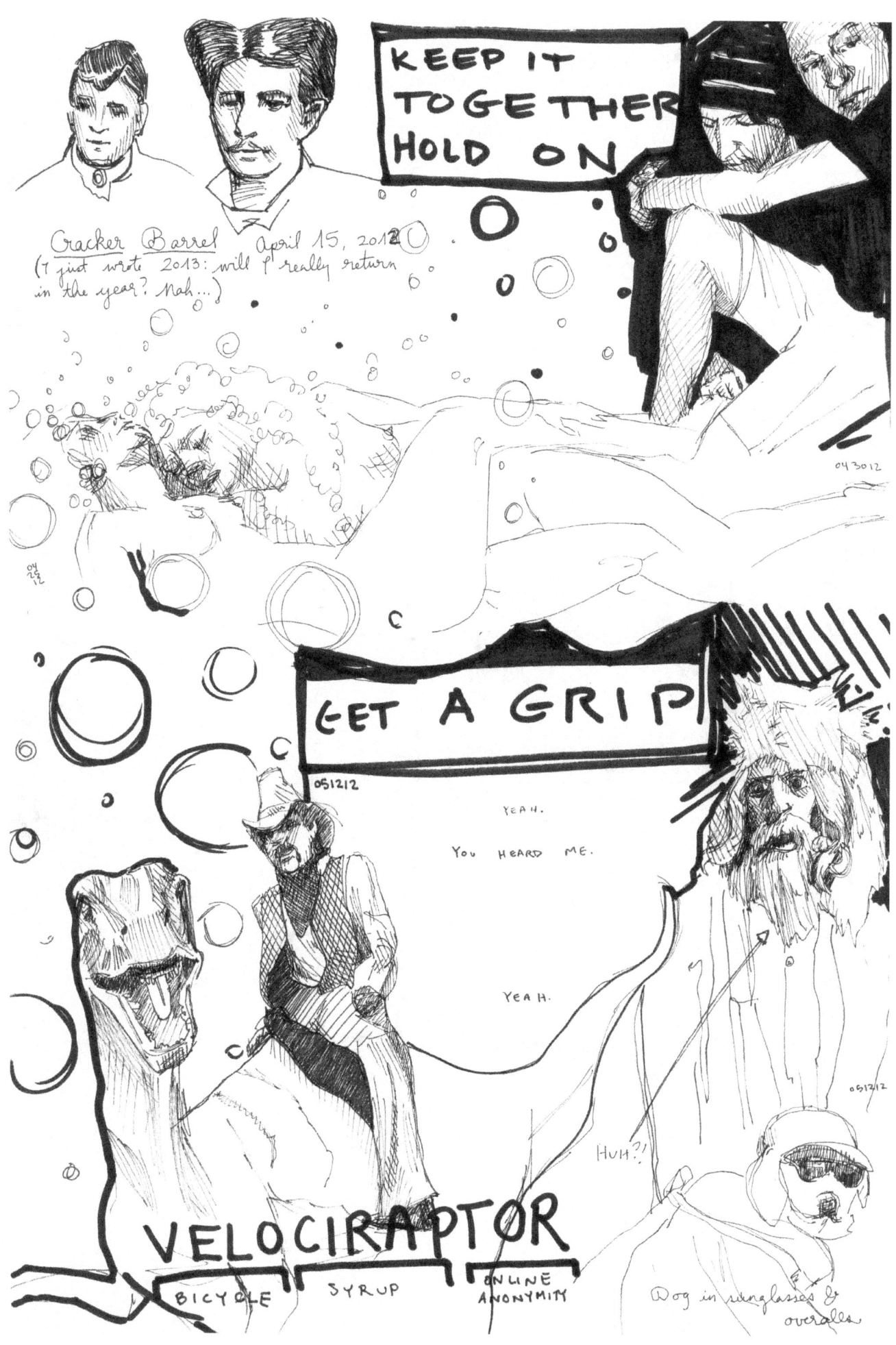

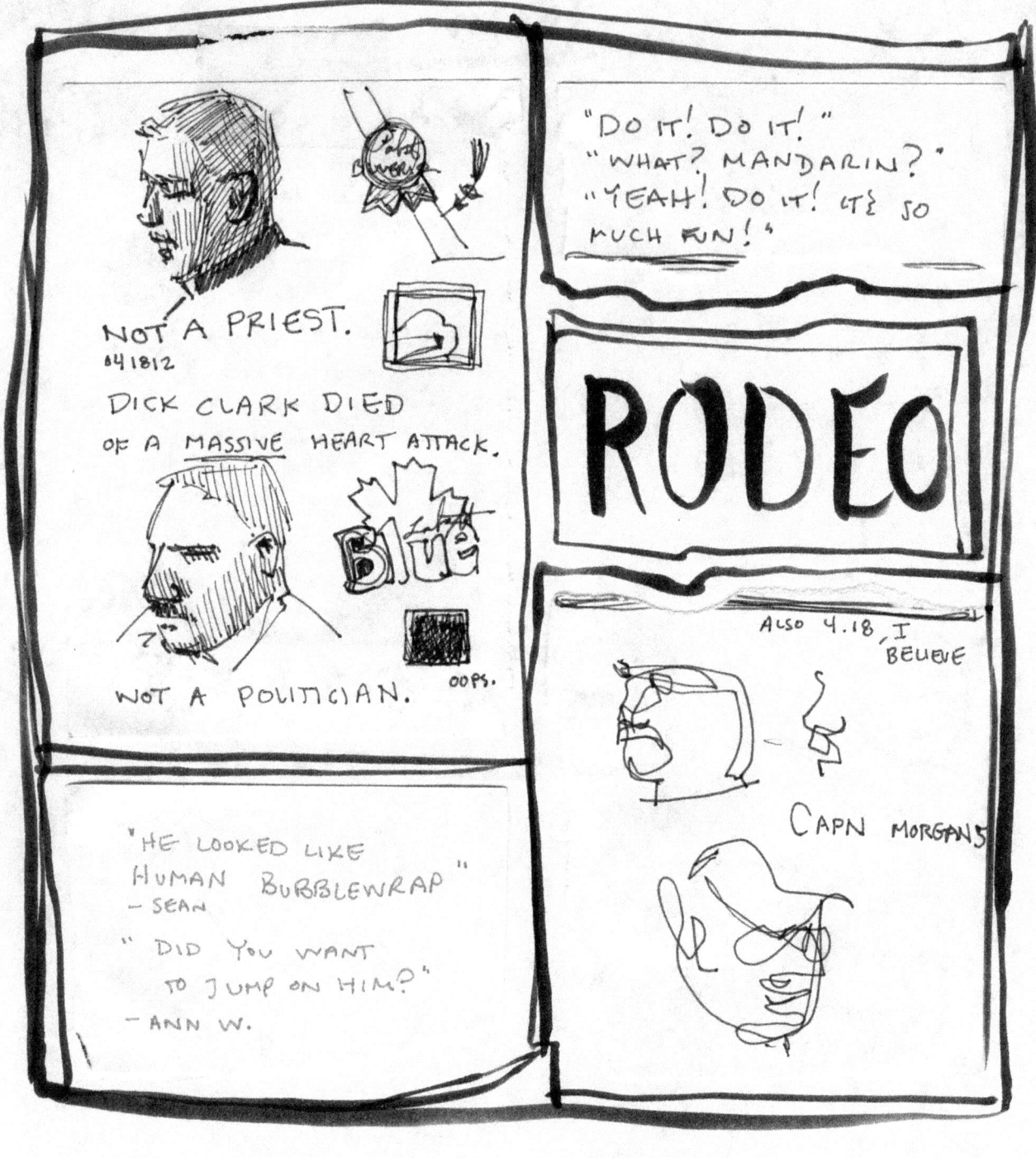

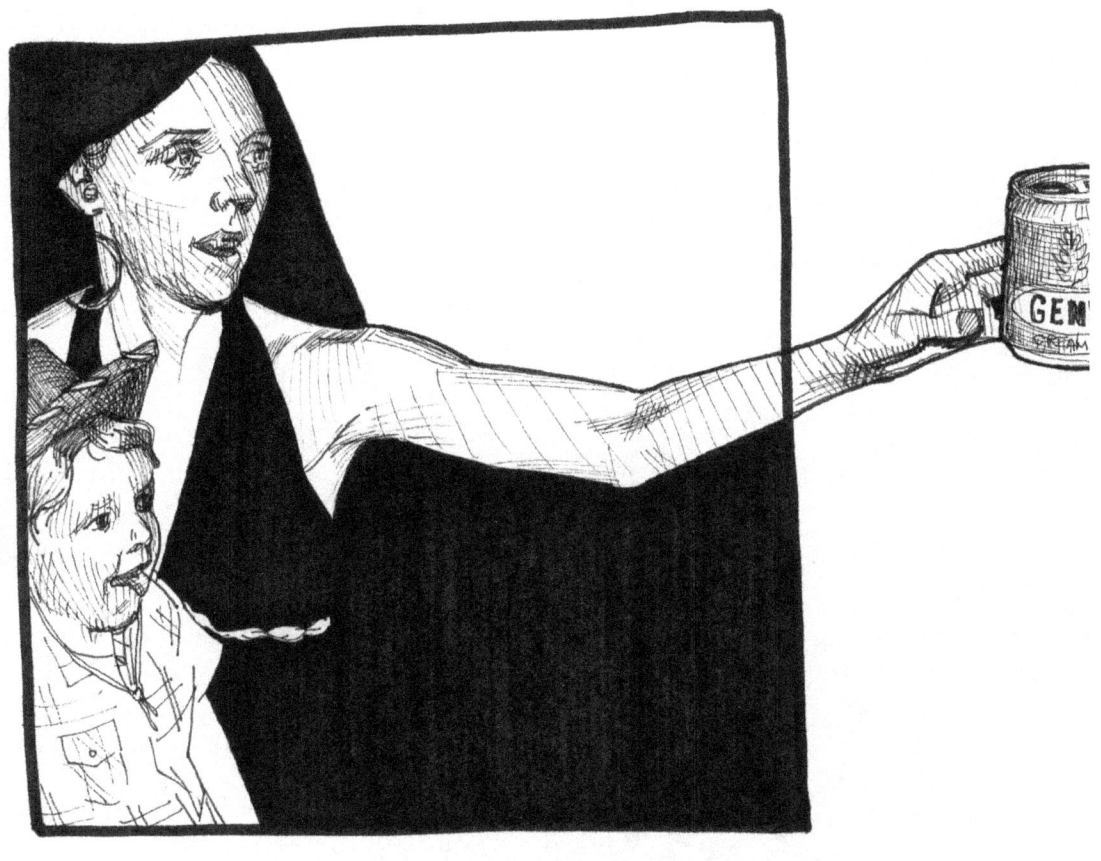

JENVER G. FAIS JR.

I WOULD RATHER NOT TALK ABOUT ALL OF THE MONEY YOU HAVE SPENT ON ME... INSTEAD, I WANT TO THANK YOU FOR HELPING ME PREPARE & HANG MY FIRST SOLO SHOW, WHICH OPENED TWO DAYS AGO. I WANT TO THANK YOU FOR 60 HOURS. I WANT TO THANK YOU FOR HOLDING MY HAND ON THE FLIGHT FROM JFK TO FRANKFURT. I WANT TO THANK YOU FOR CHANGING THE BANDAGES ON MY FINGER EVERYDAY FOR A MONTH. I WANT TO THANK YOU FOR DRIVING THE REST OF THE WAY TO WISCONSIN AFTER I GOT STUCK IN THE TOLL BOOTH. I WANT TO THANK YOU FOR TRUSTING ME & MY FIRST BOYFRIEND SO MUCH. I WANT TO THANK YOU FOR MAKING CHEESE STRAWS, FRENCH TOAST & GRILLED CHEESE SAMICHES. I WANT TO THANK YOU FOR LETTING ME YELL RIDICULOUSNESS IN CLOSE PROXIMITY. I WANT TO THANK YOU FOR BEING PATIENT FOR HUGS FROM ME. I LOVE YOU SO MUCH MOM.

(& LET'S NOT FORGET ALL OF THE POPCORN!)

051312

DEDICATED TO

THOMAS S. BUECHNER
WHO INSPIRED MY BILDUNGSREISE

MIKE & MACKEY
WHOSE JOVIAL SPIRIT LIVES ON

www.ingramcontent.com/pod-product-compliance
Lightning Source LLC
Chambersburg PA
CBHW080840170526
45158CB00009B/2600